POP MANGA COLORING BOOK

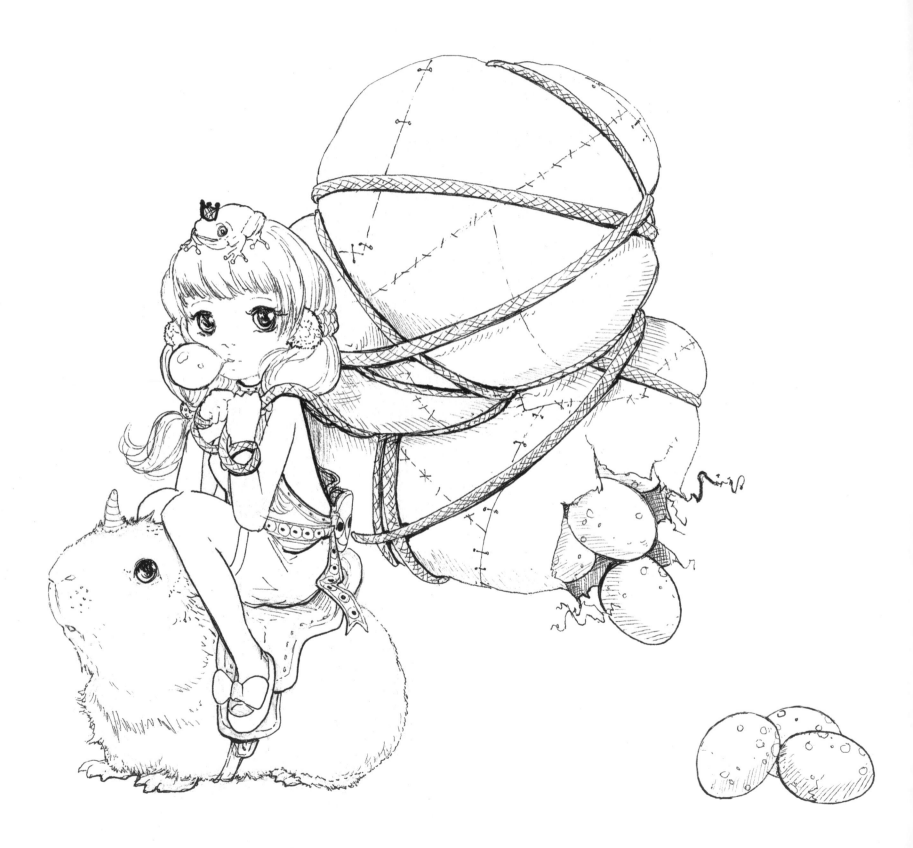

POP MANGA COLORING BOOK

A surreal journey through a cute, curious, bizarre, and beautiful world

CAMILLA d'ERRICO

WATSON-GUPTILL PUBLICATIONS

Berkeley

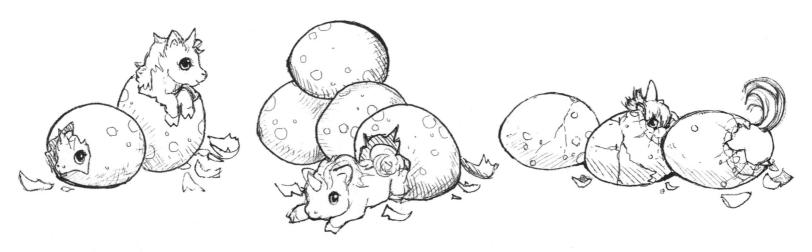

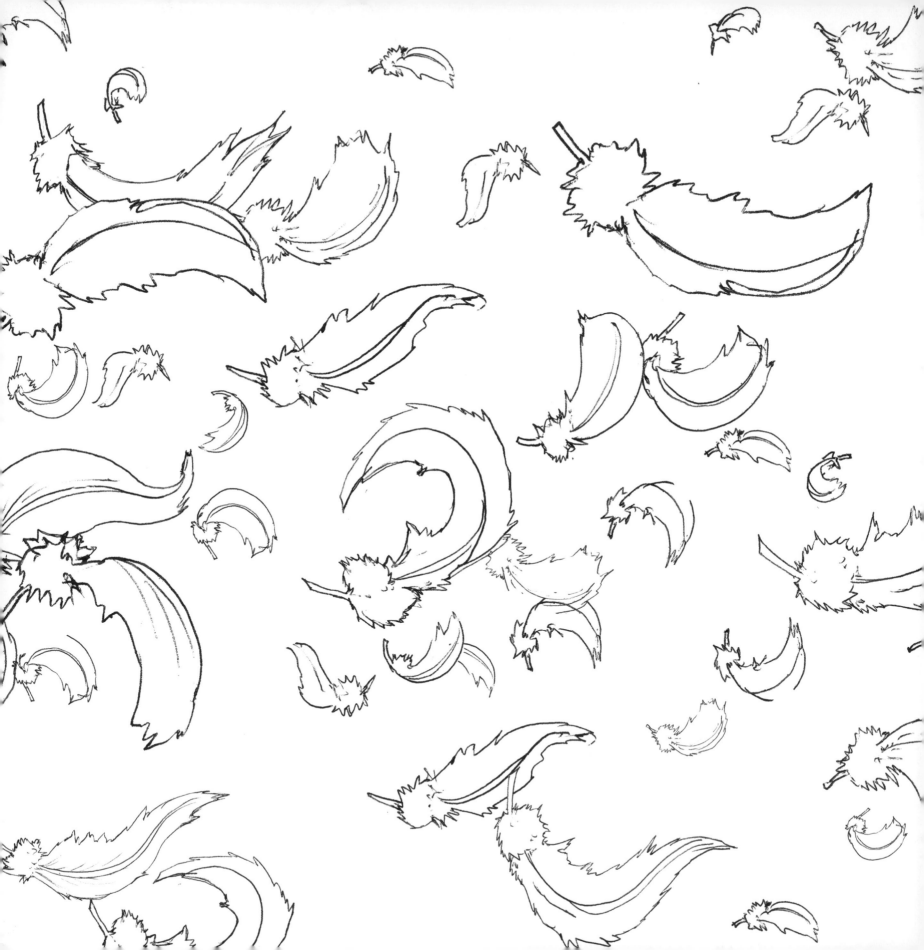

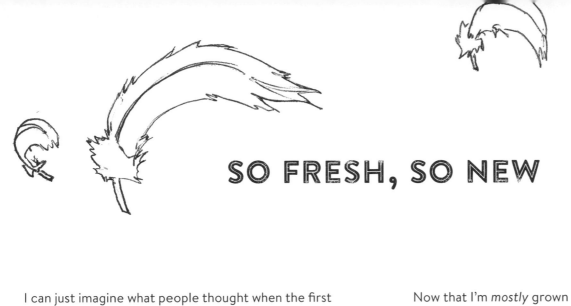

SO FRESH, SO NEW

I can just imagine what people thought when the first color TV was introduced all those years ago, watching the formerly black and white world come to life with color. The yellow brick road in *The Wizard of Oz* must have suddenly made a lot more sense to those who'd only seen it on black-and-white TVs prior! Maybe those viewers felt a little like I did when I got my first set of markers. I felt as though some wizard had just given me a whole rainbow with which to color magical worlds in whatever way I wanted. For a time, life was grand, right up until I learned about the so-called *rules*. Rules can sometimes be rigid and confining, and have a "delightful" habit of taking the wind out of your creative sails.

The first real rule I was taught as a child was *Color inside the lines*. Along with being the first rule I learned, it was also the first one that I simply *had to* break. I was much more interested in watching colors appear on the paper as I scribbled willy-nilly. It was hypnotizing. My young, little brain was thinking way too fast for my tiny hands to keep up. *Get the color on the paper* was the only goal I had in mind. I was a creative kid and my coloring was in abstract overdrive. I would go wildly outside the lines, straight over the lines, and, occasionally, right off the page and entirely onto the table! New rule from Mom: *Don't color the table*. (Some rules are just no fun at all.)

Now that I'm *mostly* grown up I've finally created a coloring book, not only for kids but also for the inner child in everyone. Nothing in the world makes me feel more like a kid again than the smell of a pack of crayons and a big blank coloring book full of possibilities.

In this collection, I hope to provide you with a really interesting and unique experience. I want whomever picks up this book and flips through its pages to feel an irresistible urge to fill in all its images with all sorts of vivid colors. You'll be surprised by how my pieces have changed for this coloring book. I have repurposed some of my artwork, adding cool patterned backgrounds to fill the negative space—and to give you more elements to color. Ha! Ha!

Hey peeps! I'm Inku's and Zu's cute cousin. My name is Ayako, but you can call me A! Like the Fonz, you know? Ehhhhhh!!

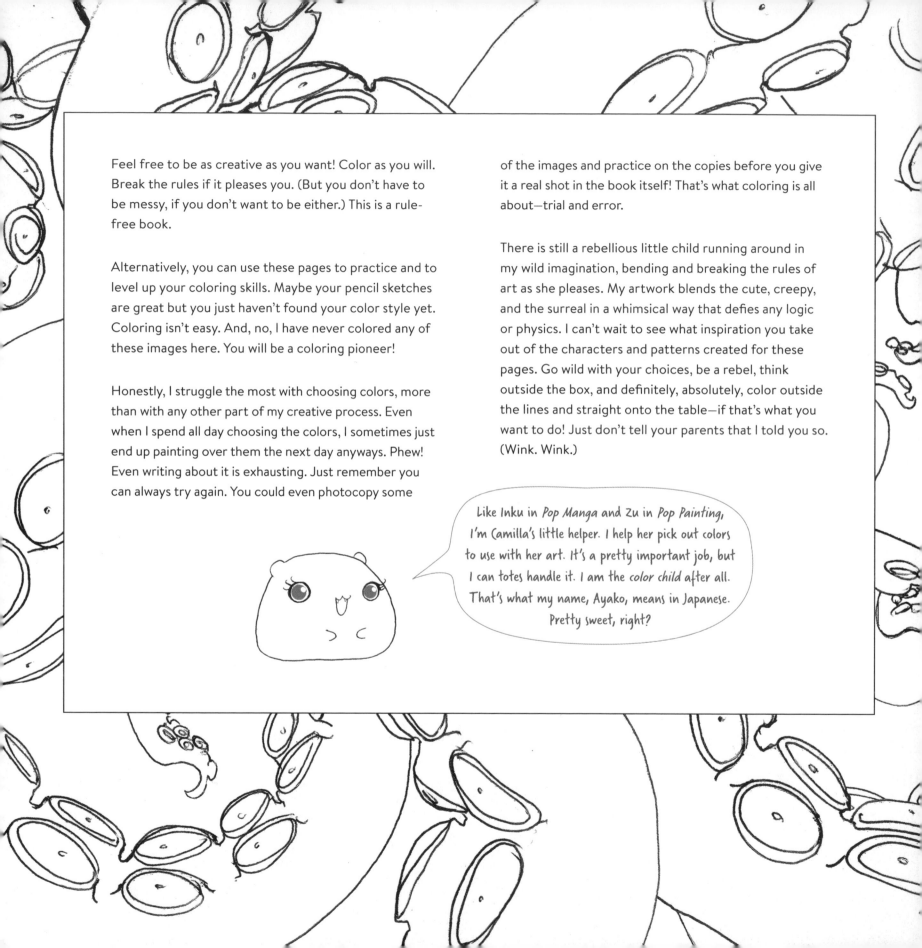

Feel free to be as creative as you want! Color as you will. Break the rules if it pleases you. (But you don't have to be messy, if you don't want to be either.) This is a rule-free book.

Alternatively, you can use these pages to practice and to level up your coloring skills. Maybe your pencil sketches are great but you just haven't found your color style yet. Coloring isn't easy. And, no, I have never colored any of these images here. You will be a coloring pioneer!

Honestly, I struggle the most with choosing colors, more than with any other part of my creative process. Even when I spend all day choosing the colors, I sometimes just end up painting over them the next day anyways. Phew! Even writing about it is exhausting. Just remember you can always try again. You could even photocopy some of the images and practice on the copies before you give it a real shot in the book itself! That's what coloring is all about—trial and error.

There is still a rebellious little child running around in my wild imagination, bending and breaking the rules of art as she pleases. My artwork blends the cute, creepy, and the surreal in a whimsical way that defies any logic or physics. I can't wait to see what inspiration you take out of the characters and patterns created for these pages. Go wild with your choices, be a rebel, think outside the box, and definitely, absolutely, color outside the lines and straight onto the table—if that's what you want to do! Just don't tell your parents that I told you so. (Wink. Wink.)

Like Inku in *Pop Manga* and Zu in *Pop Painting*, I'm Camilla's little helper. I help her pick out colors to use with her art. It's a pretty important job, but I can totes handle it. I am the *color child* after all. That's what my name, Ayako, means in Japanese. Pretty sweet, right?

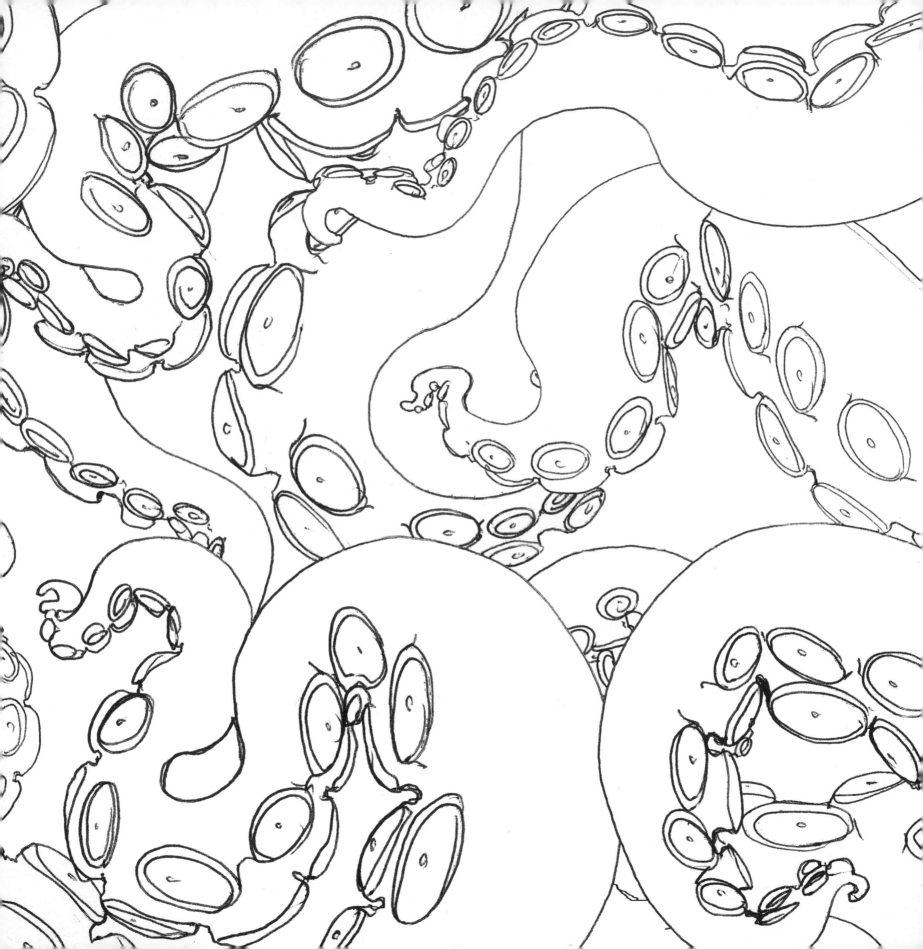

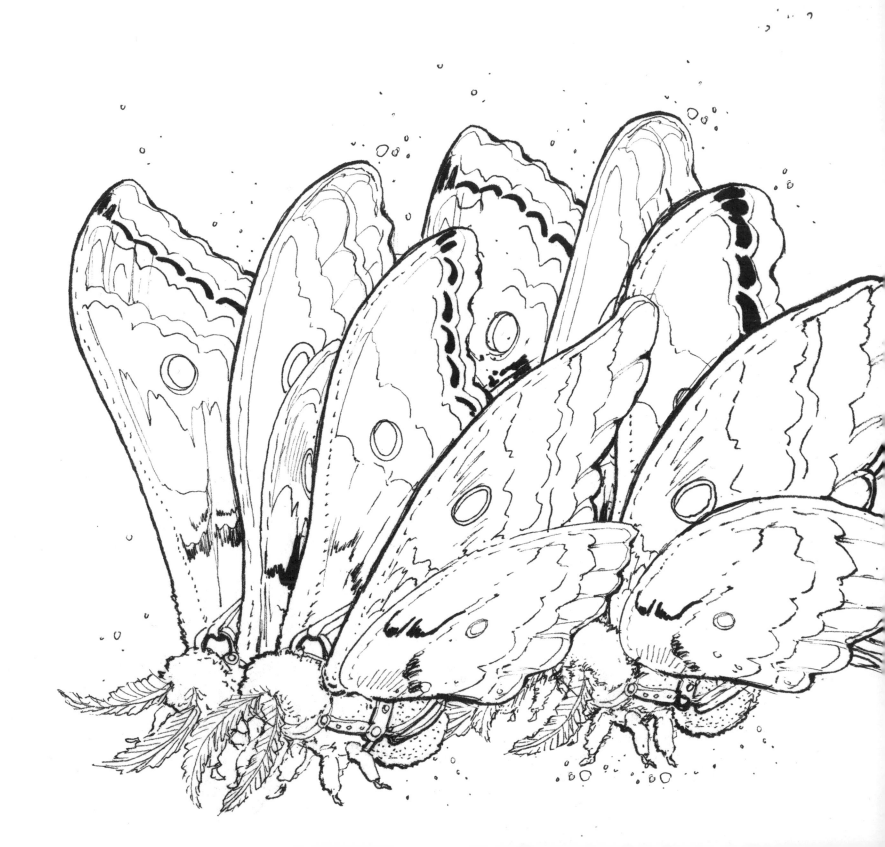

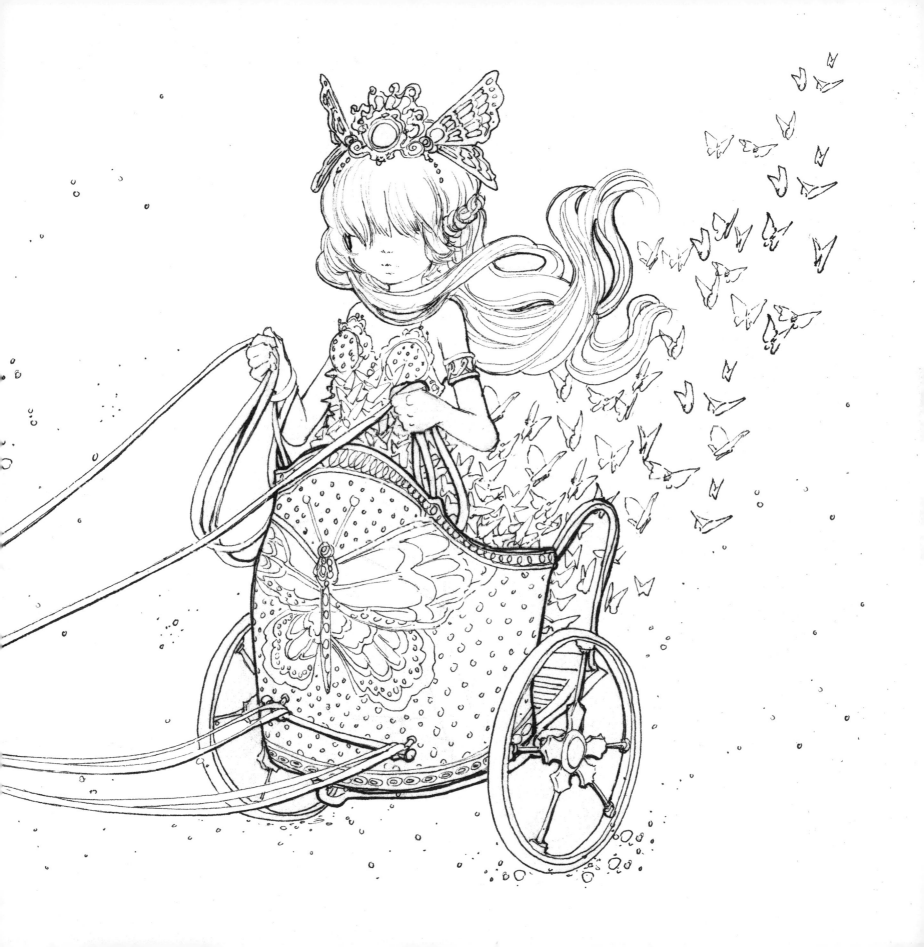

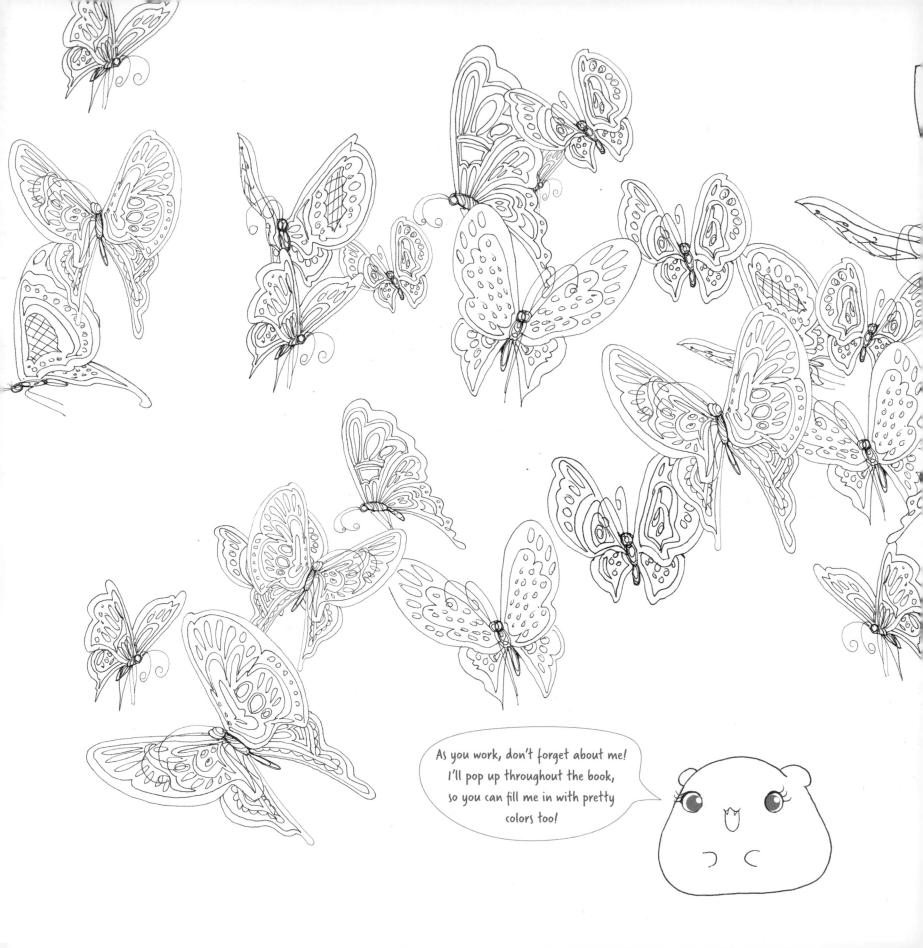

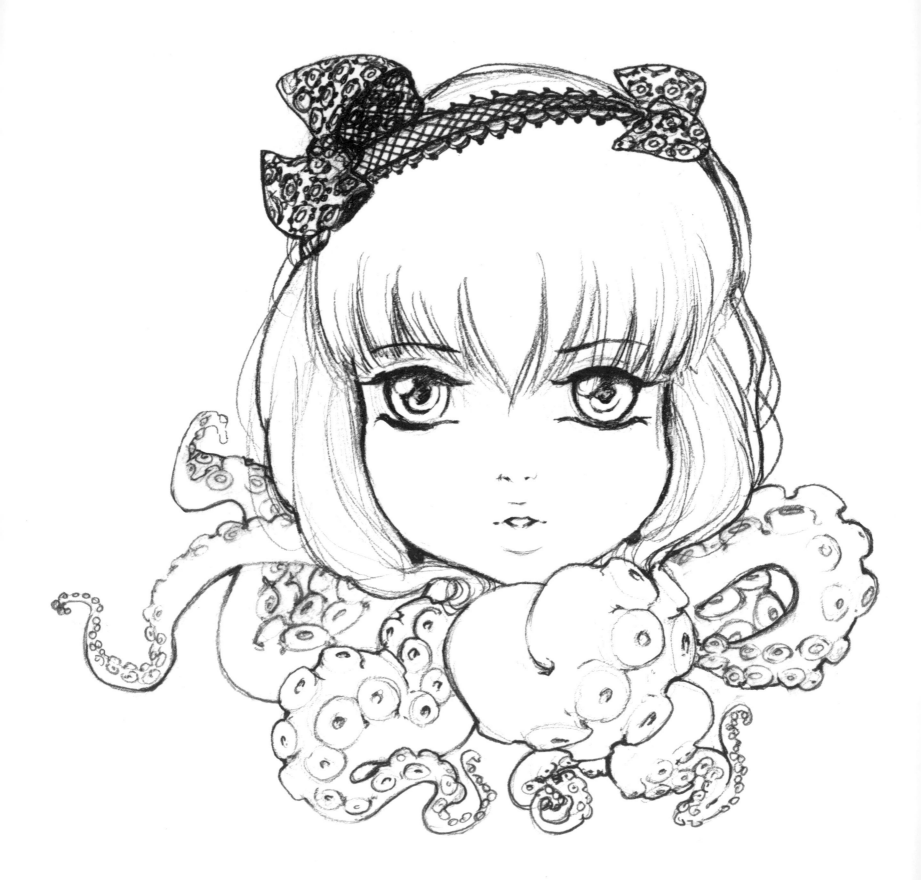

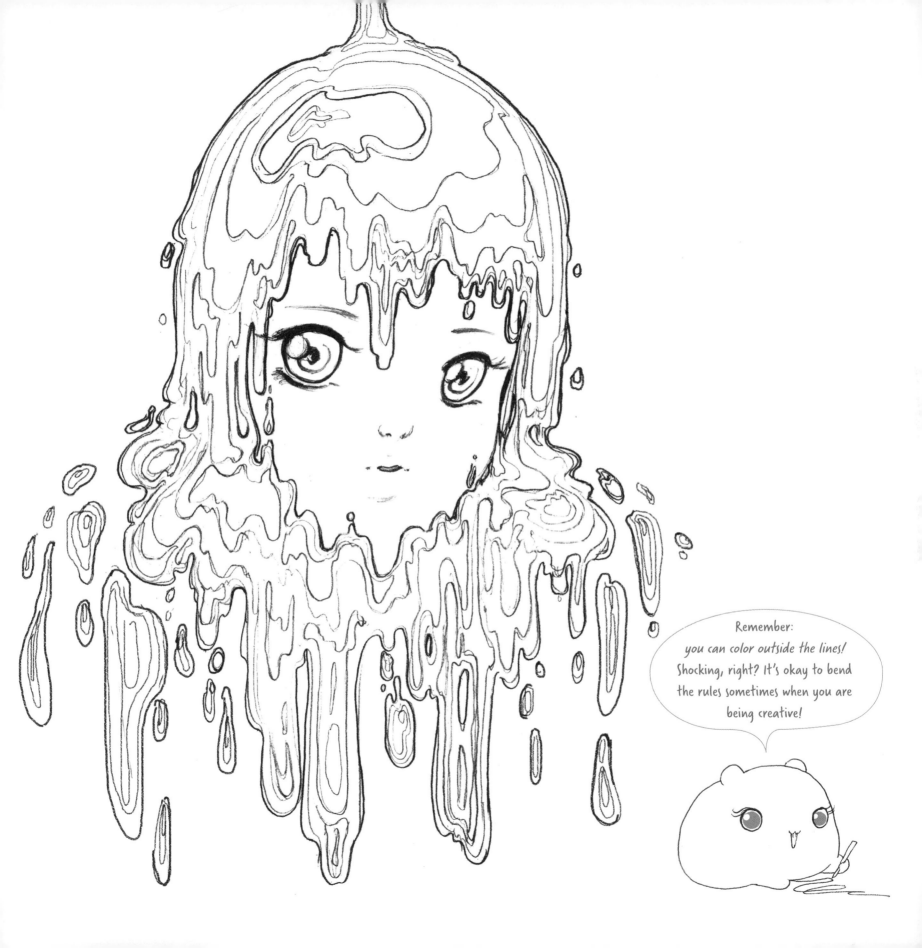

Remember:
you can color outside the lines!
Shocking, right? It's okay to bend
the rules sometimes when you are
being creative!

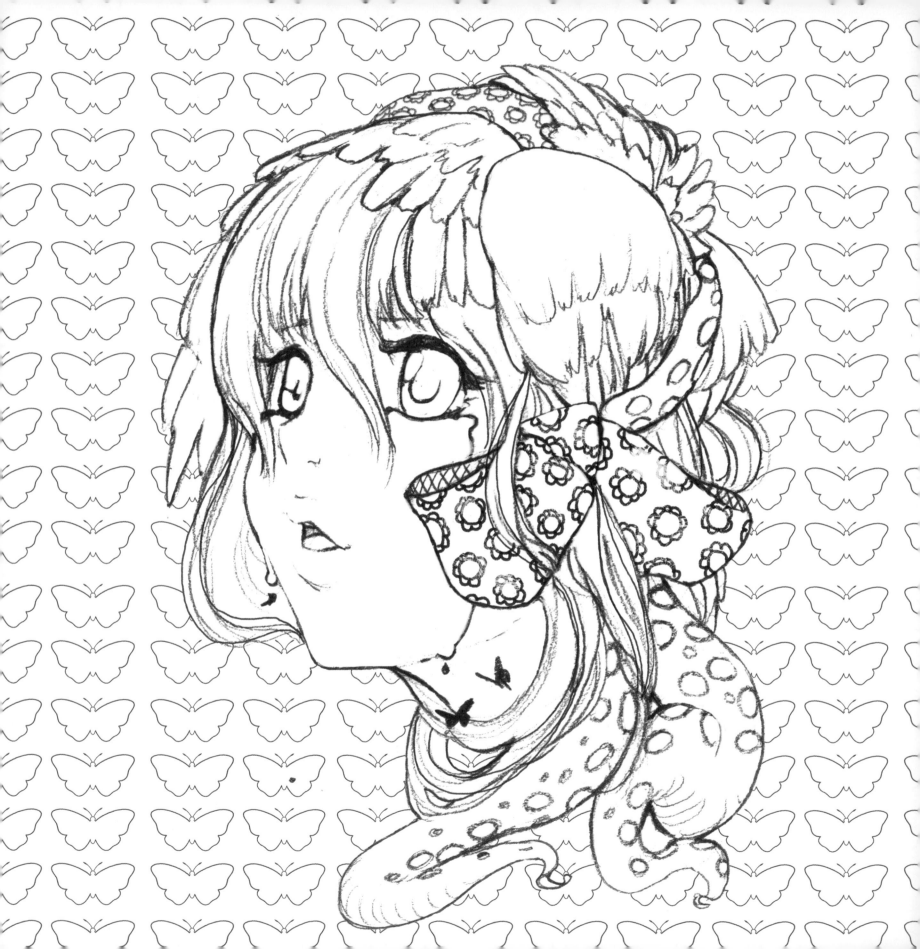

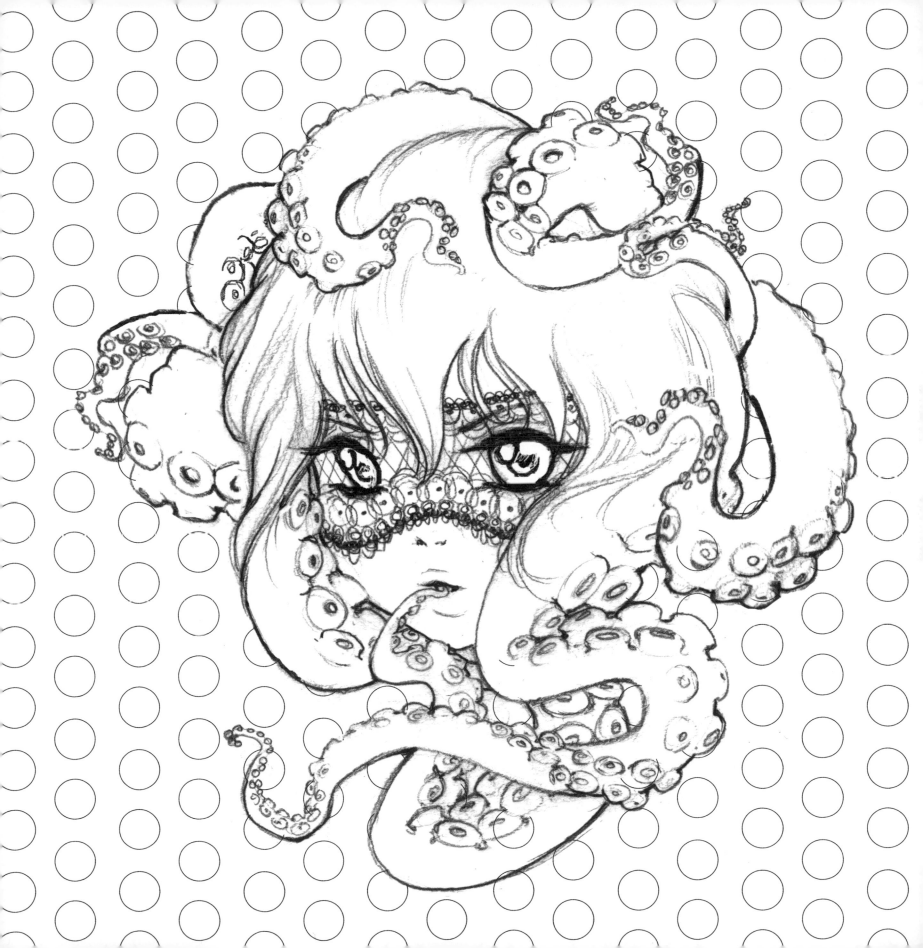

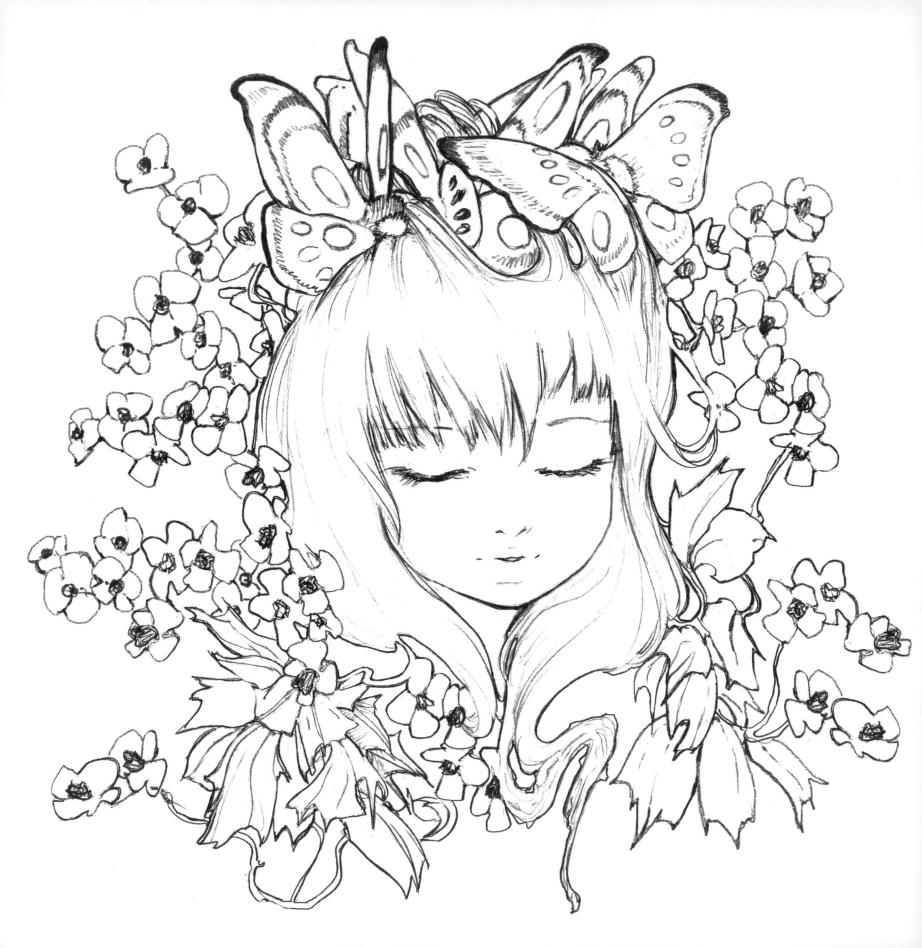

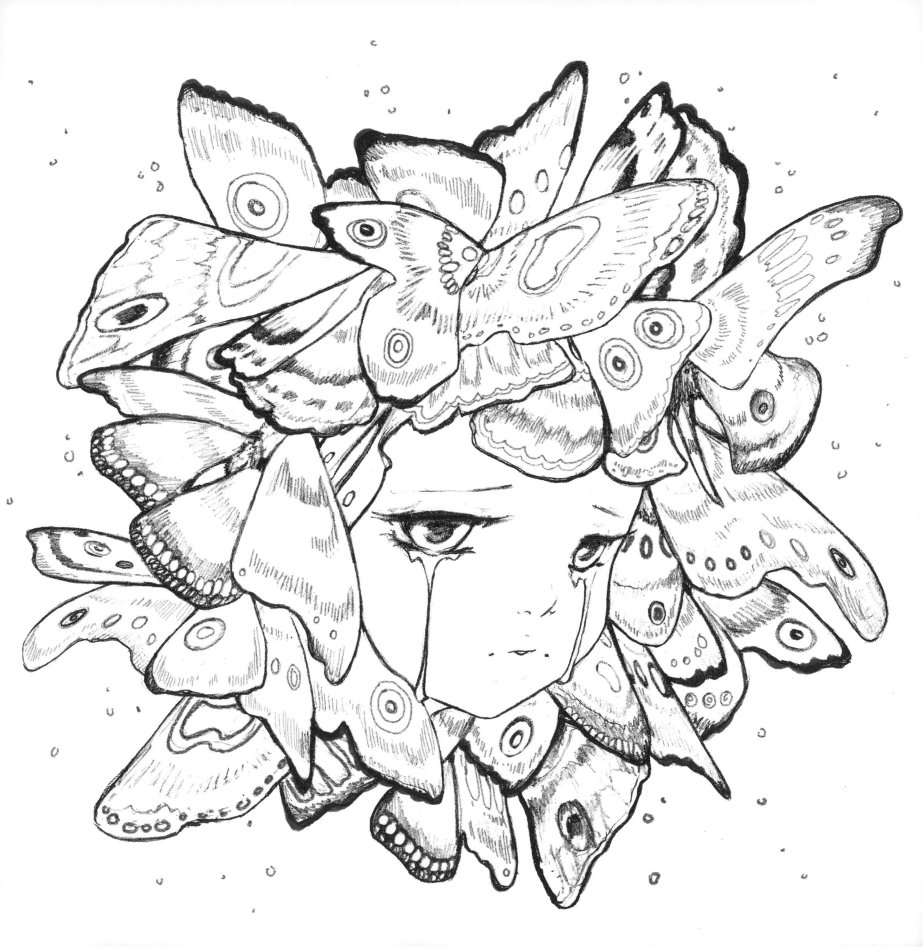

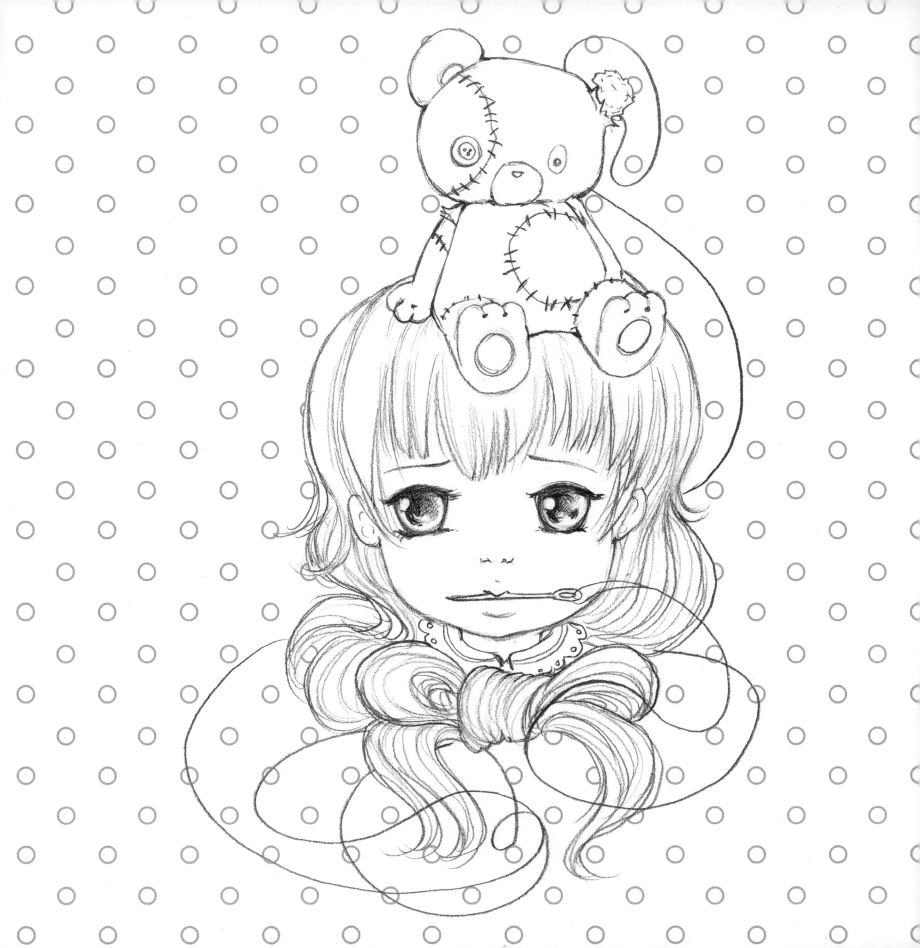

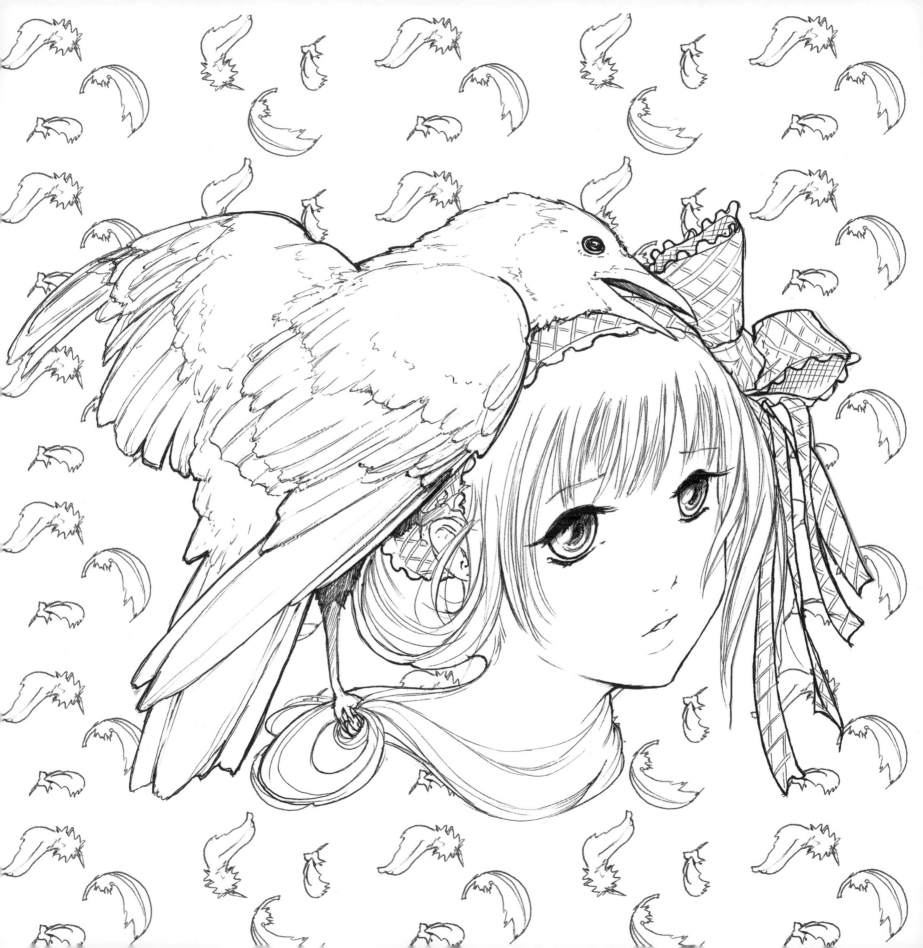

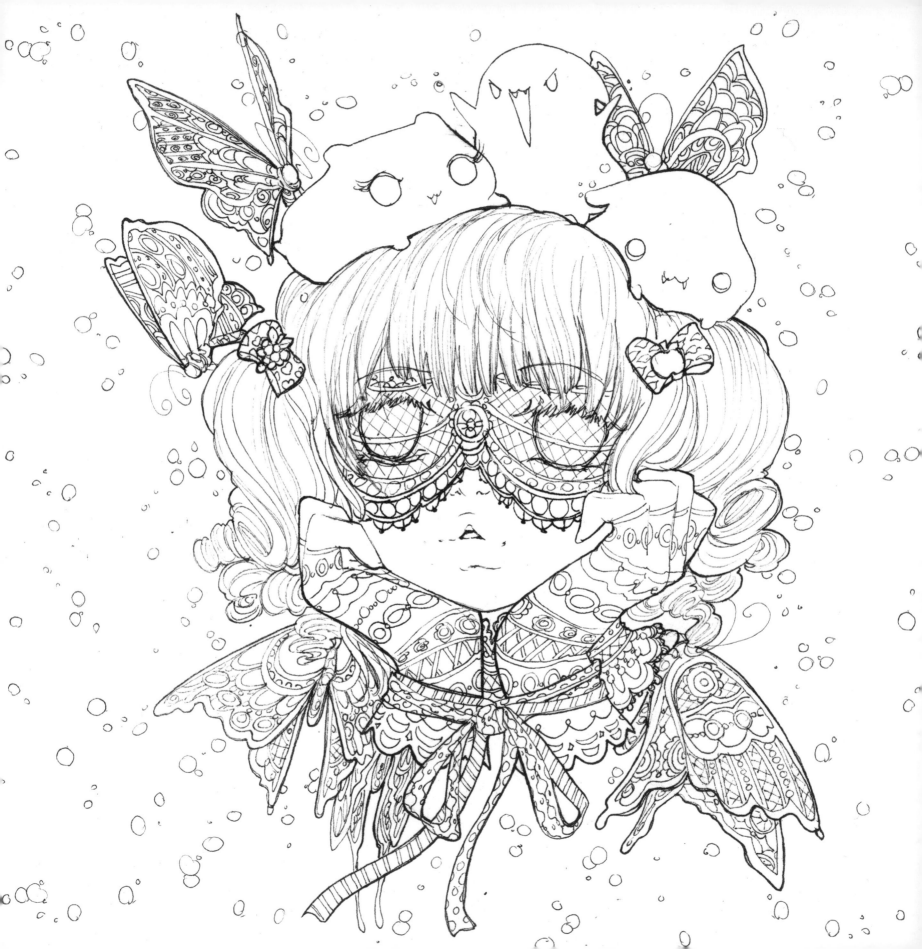

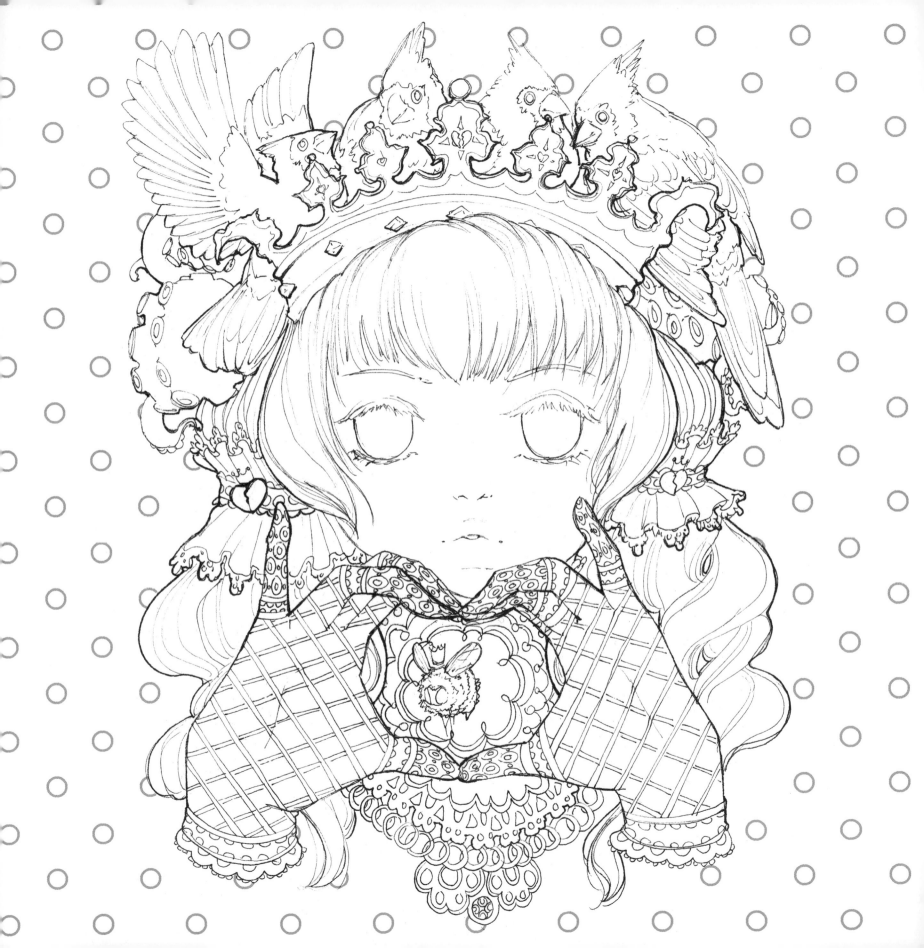

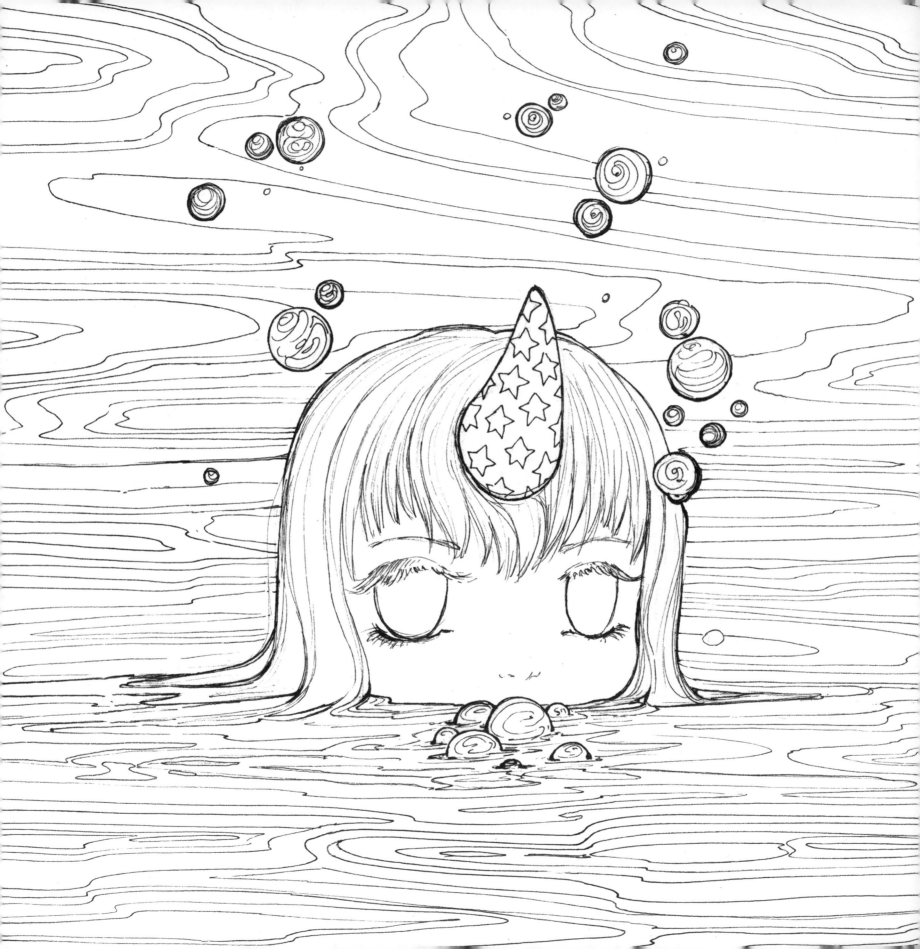

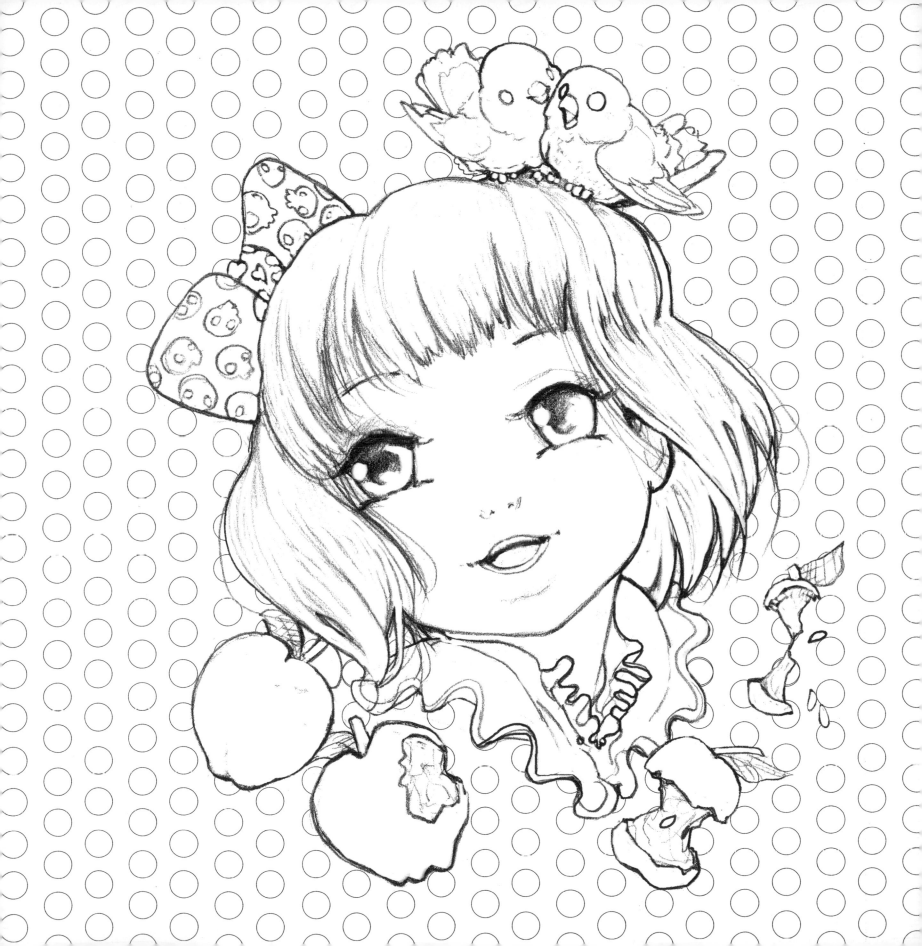

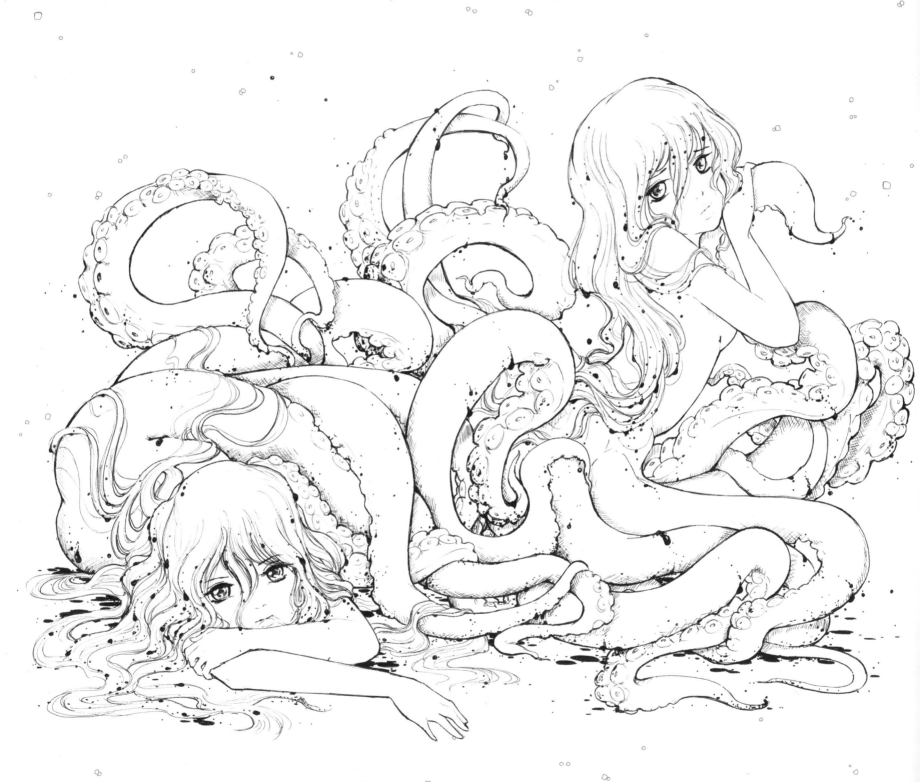

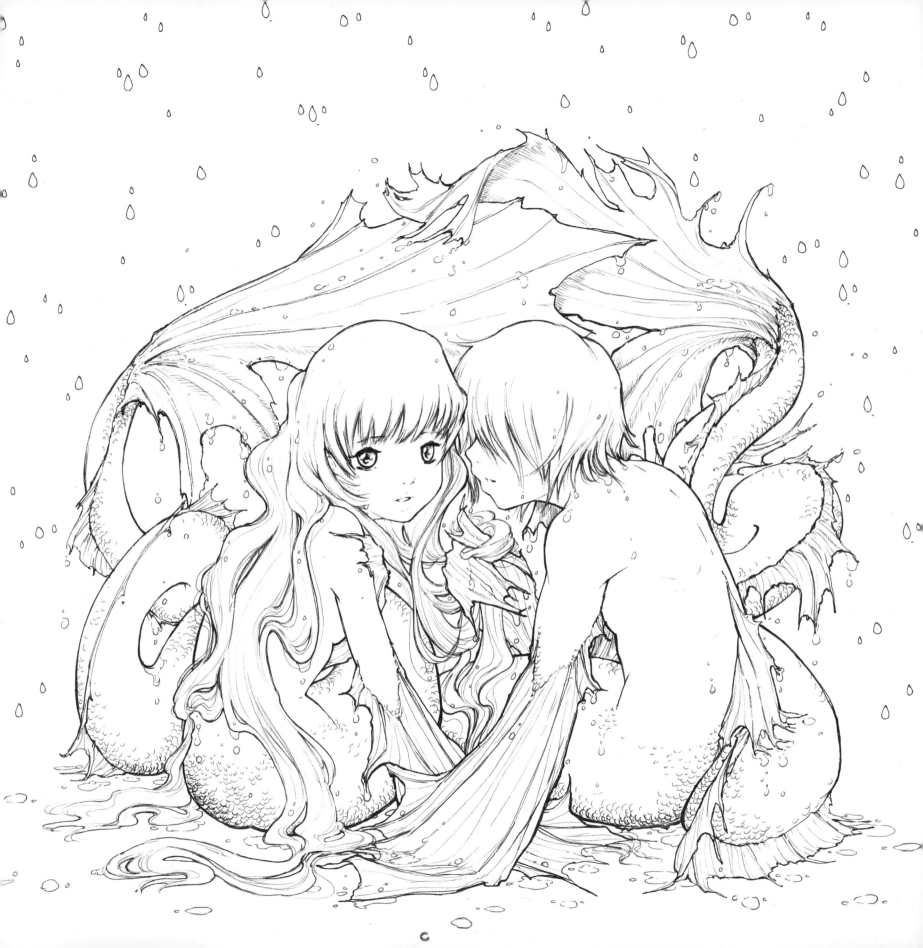

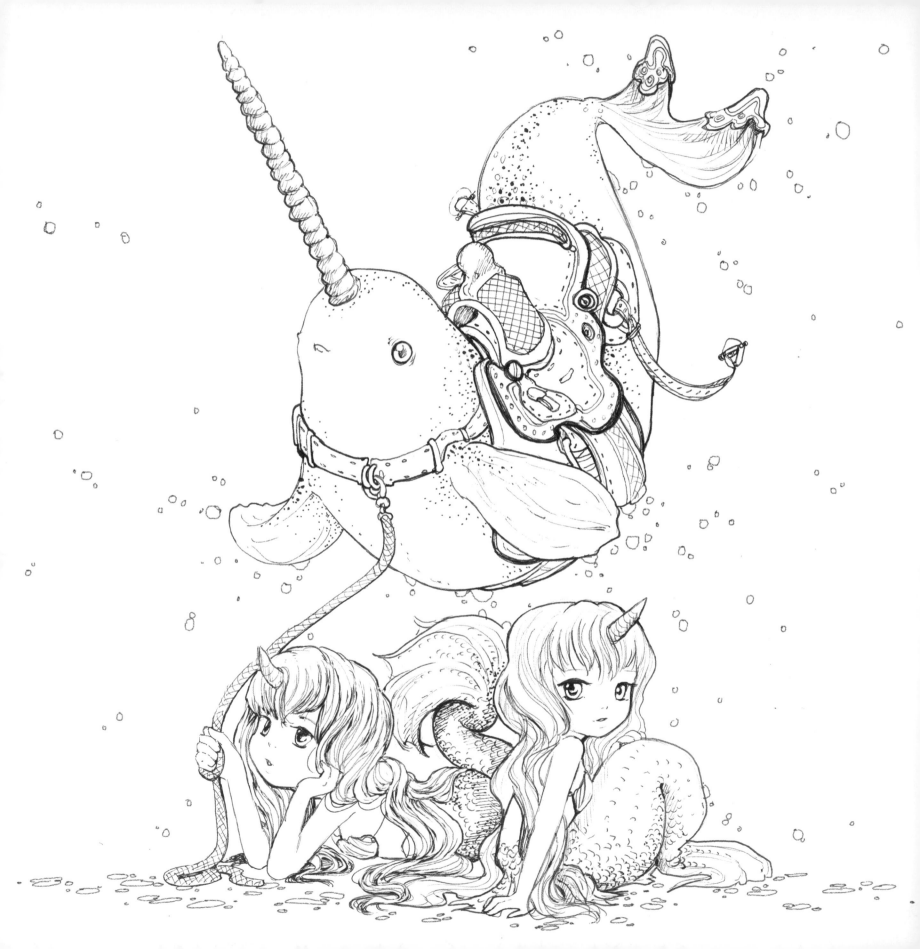

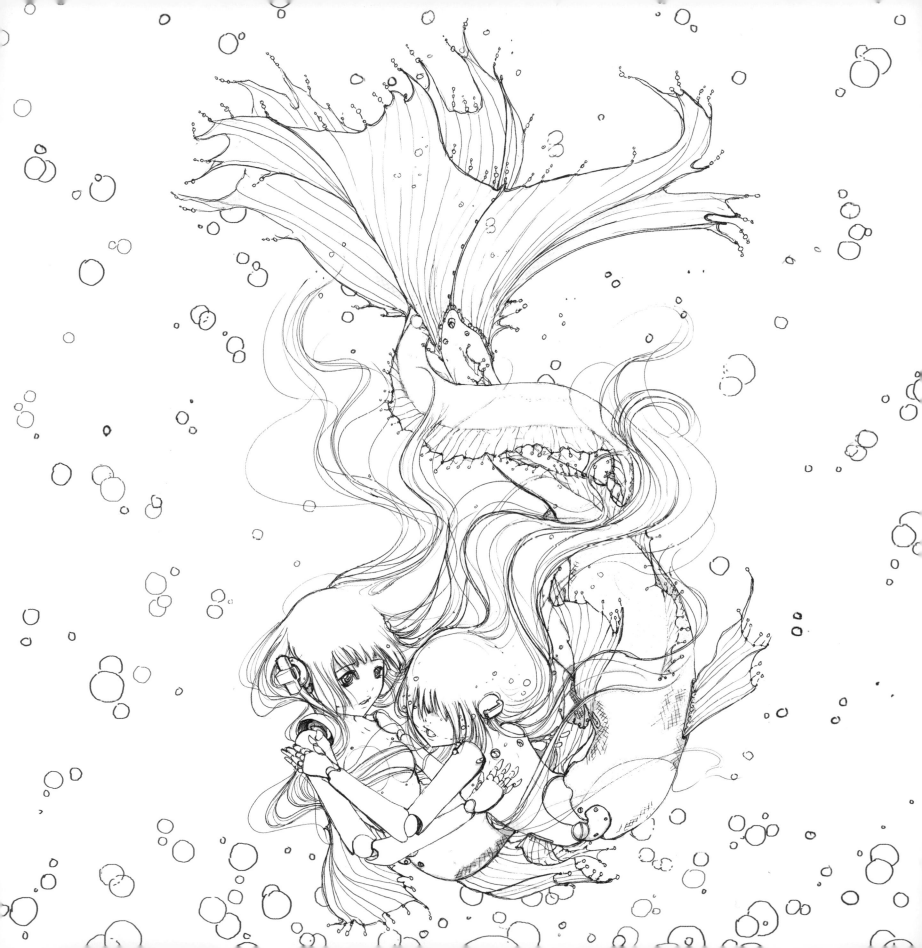

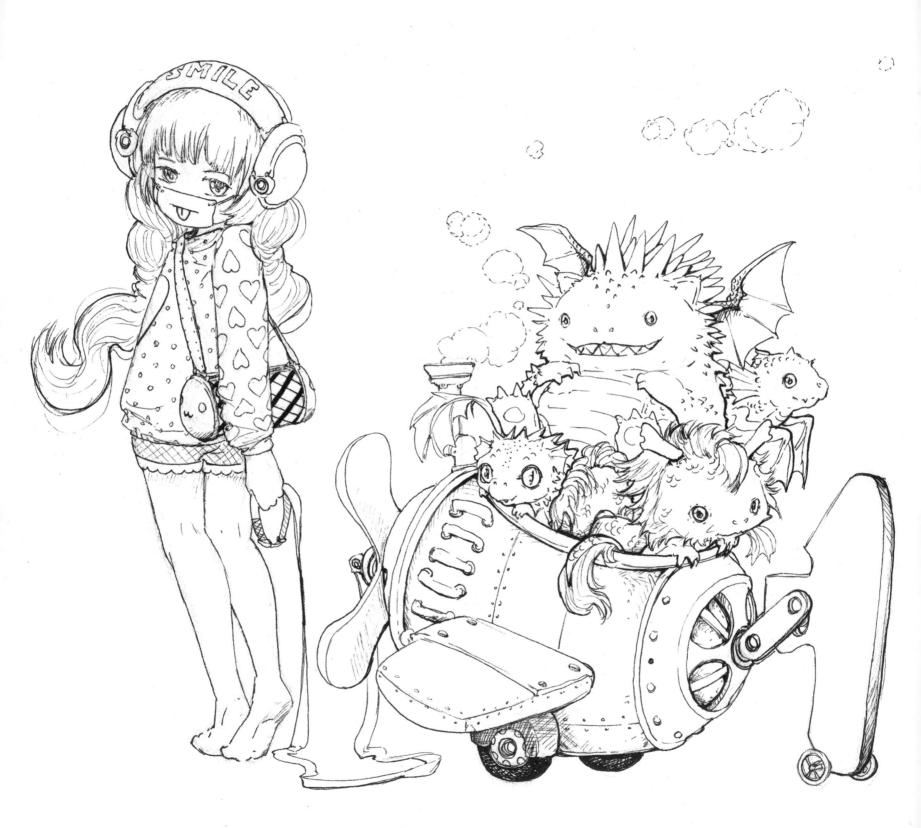

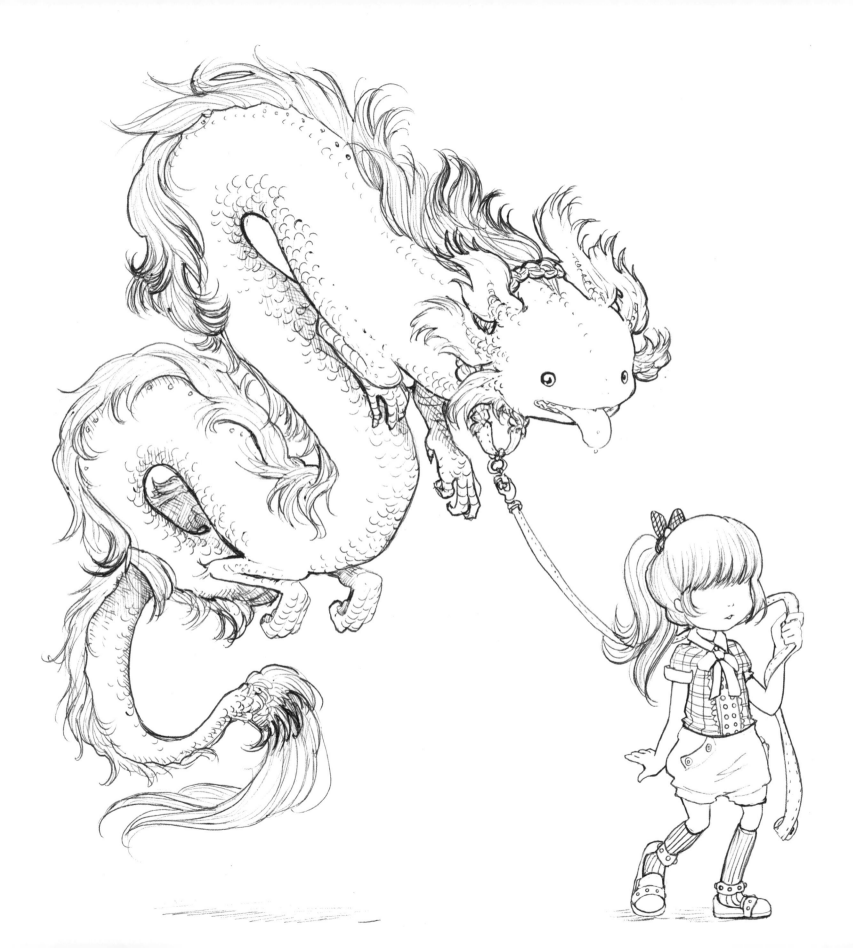

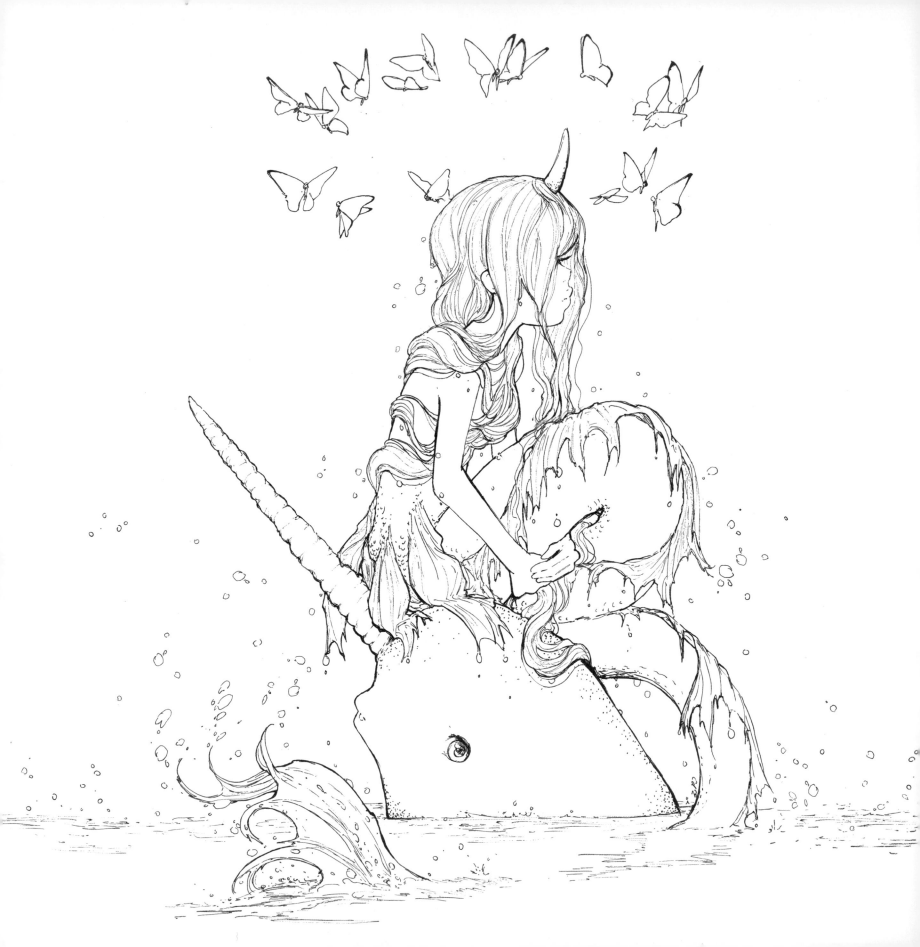

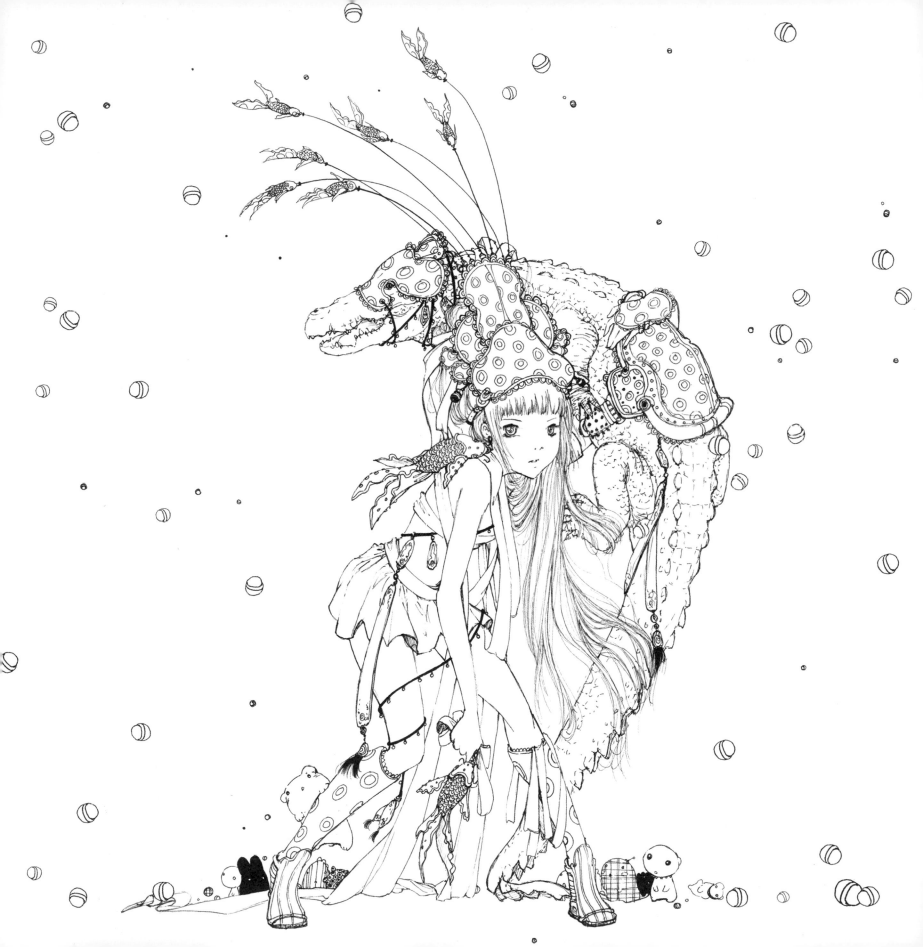

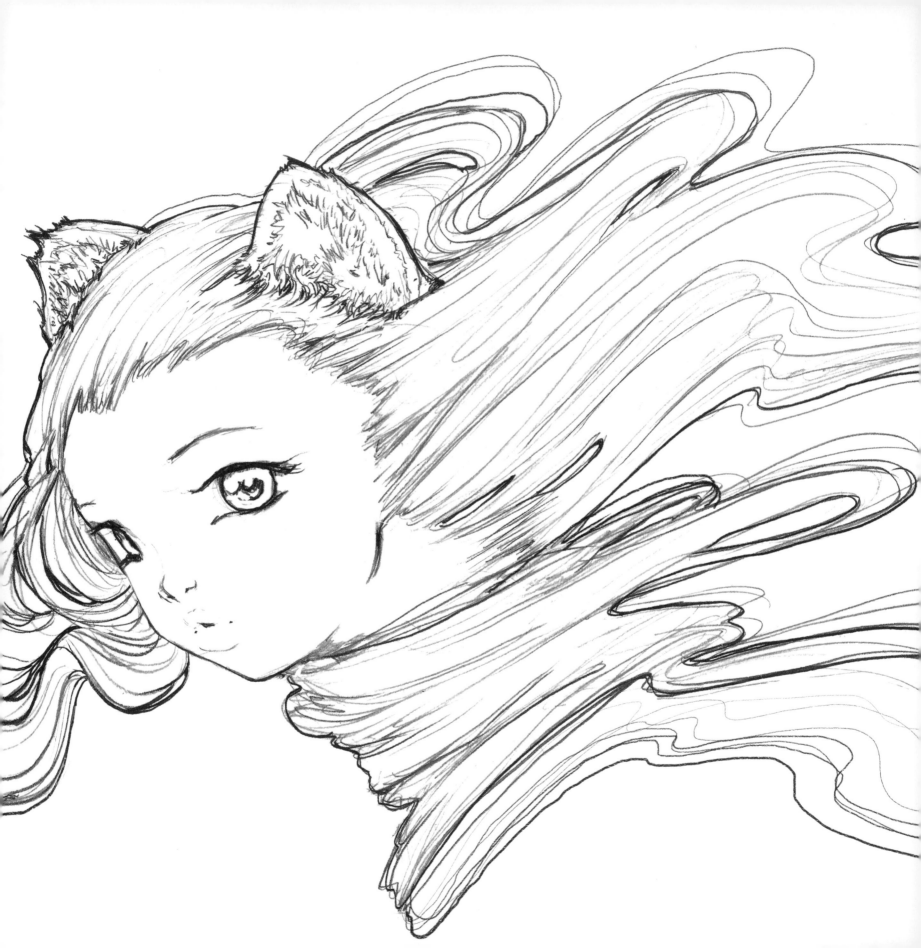

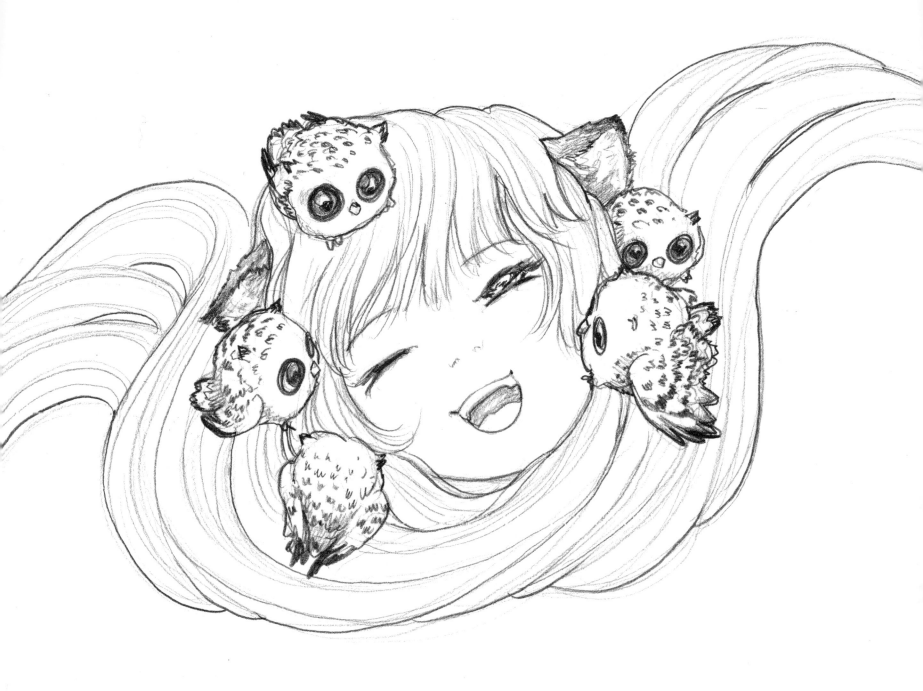

It's totes okay to use whatever colors you want! Cami-chan and I learned a long time ago to use whatever we want when coloring! *Pink* hair, *yellow* eyes, *blue* owls, oh yeah, go nuts! Let your freak flags fly, peeps!

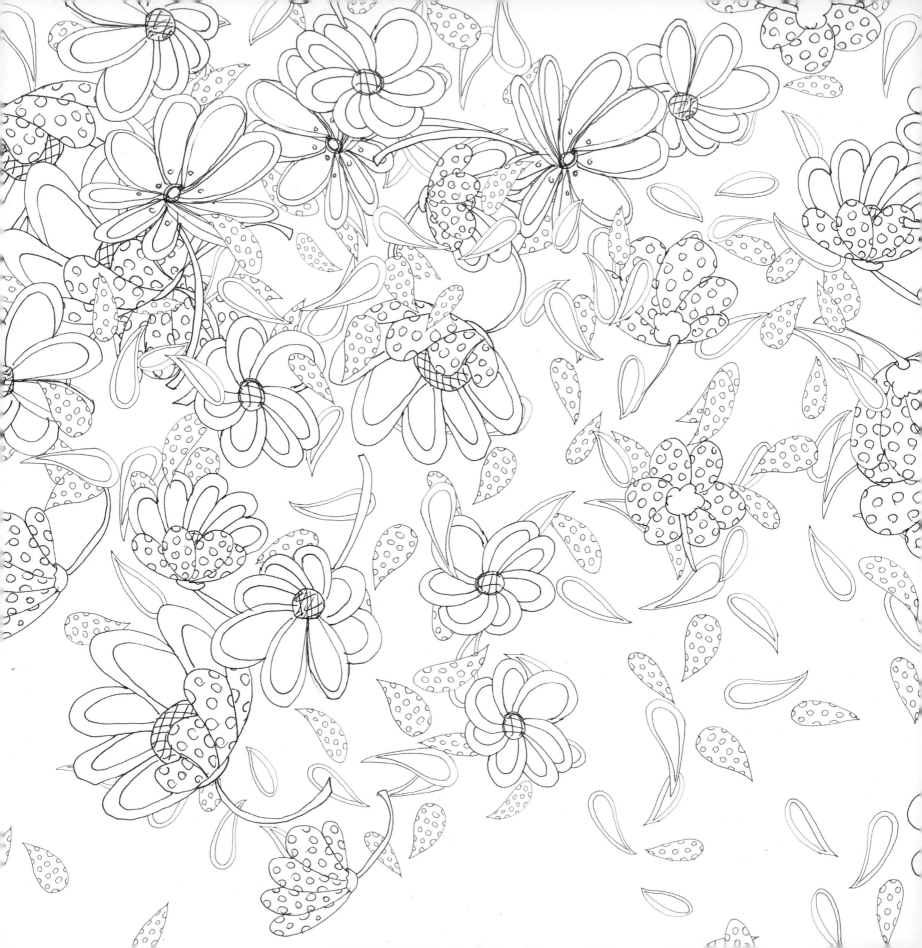

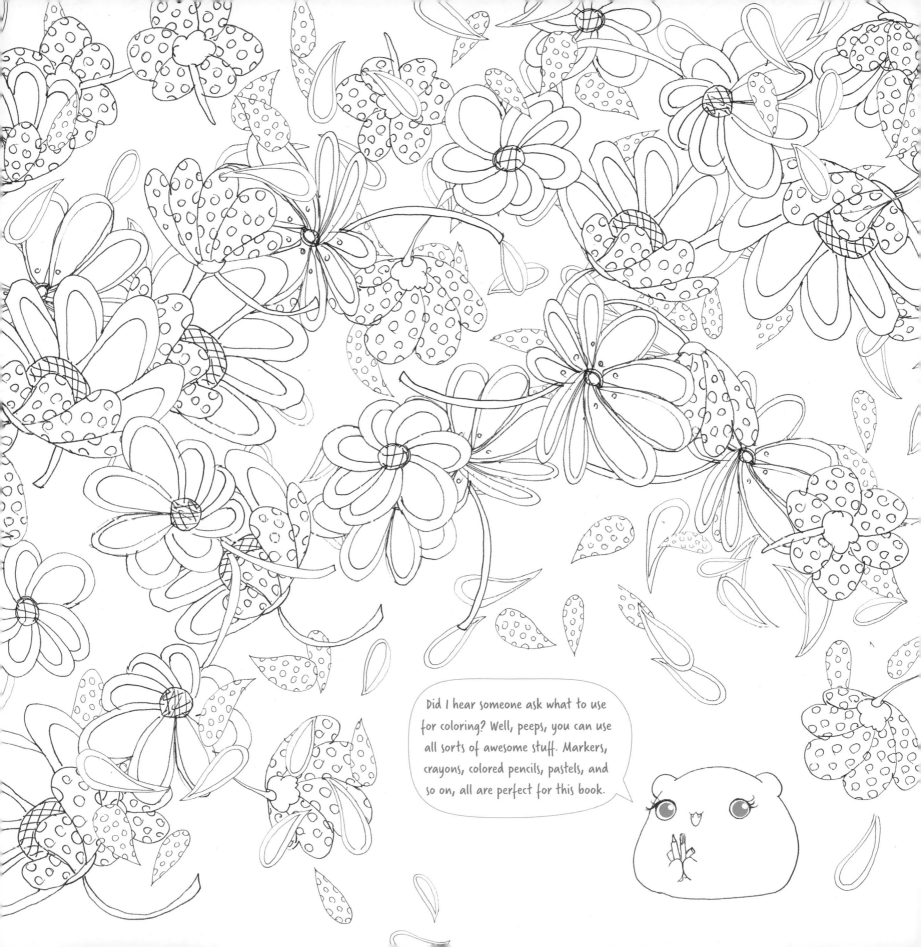

Did I hear someone ask what to use for coloring? Well, peeps, you can use all sorts of awesome stuff. Markers, crayons, colored pencils, pastels, and so on, all are perfect for this book.

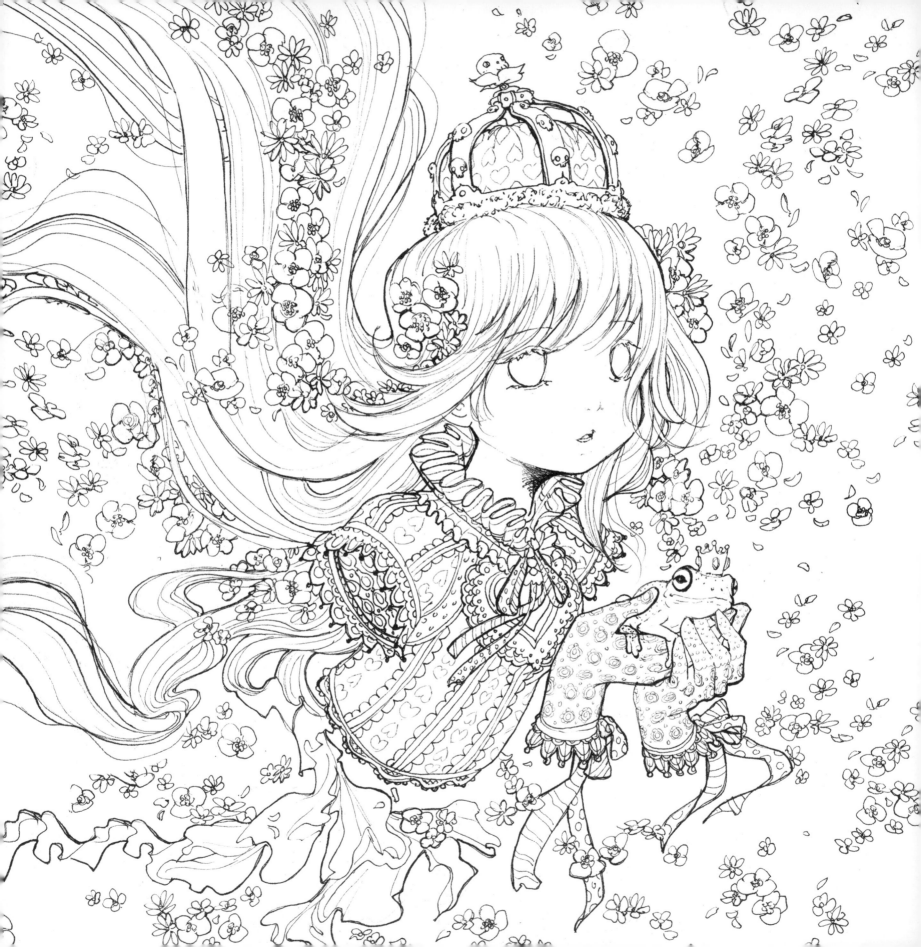

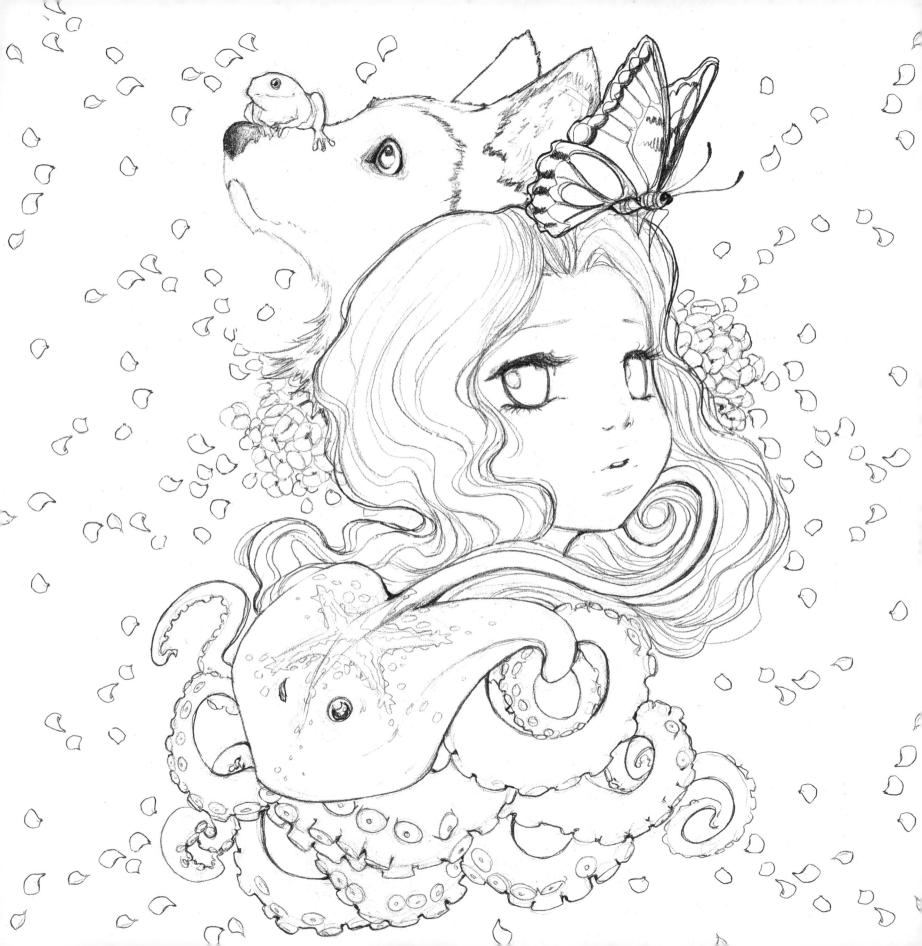

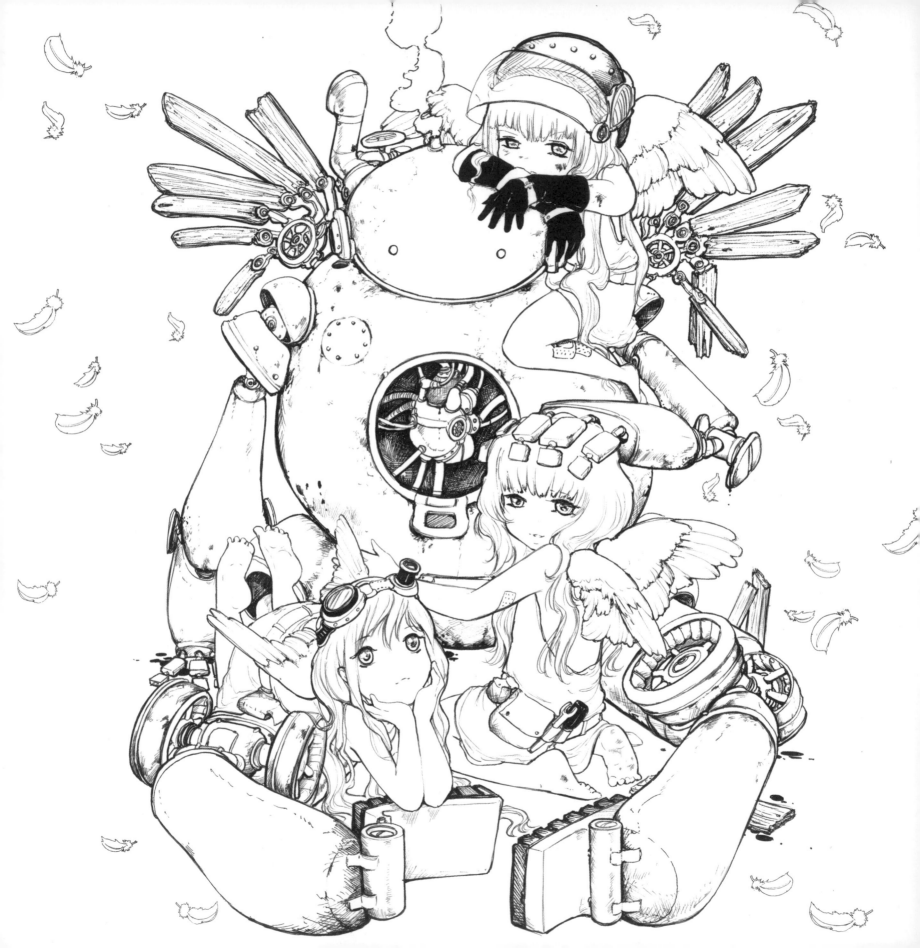

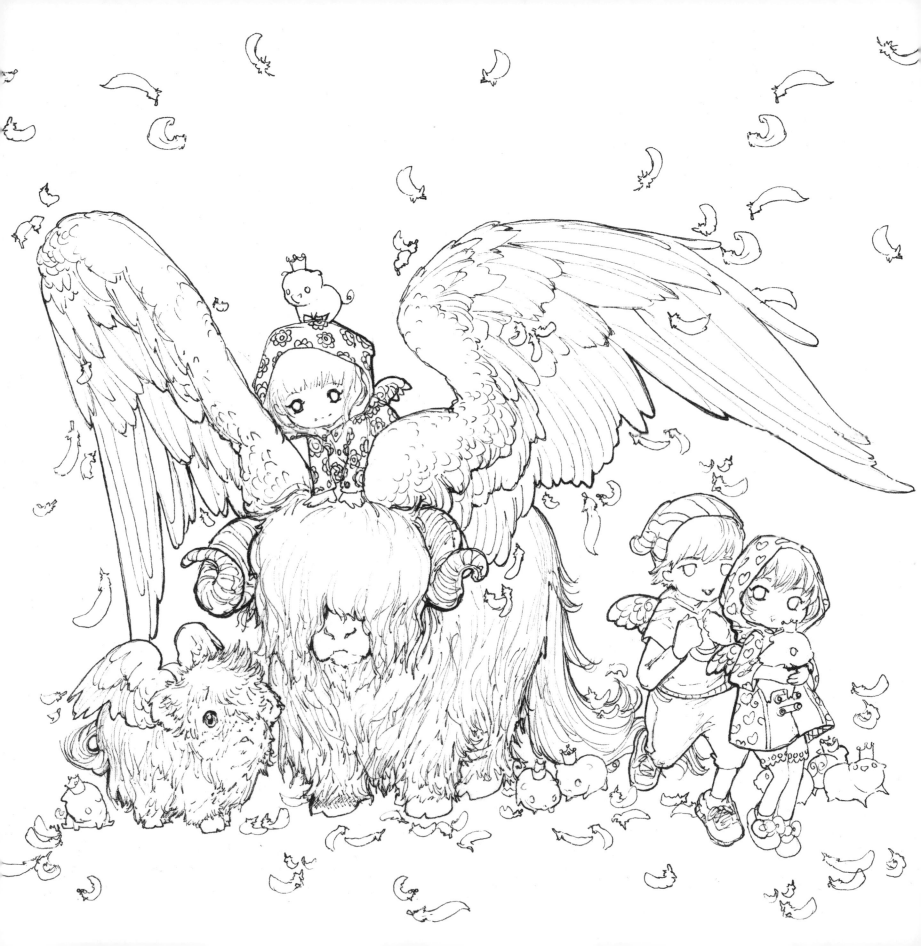

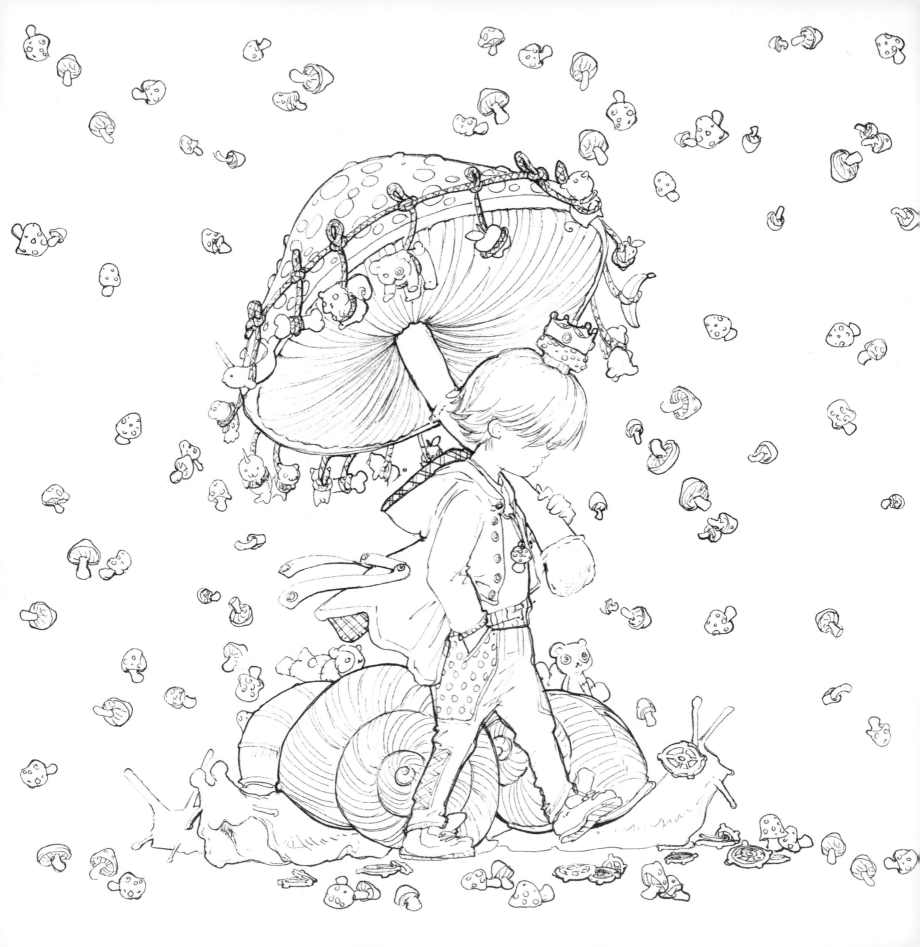

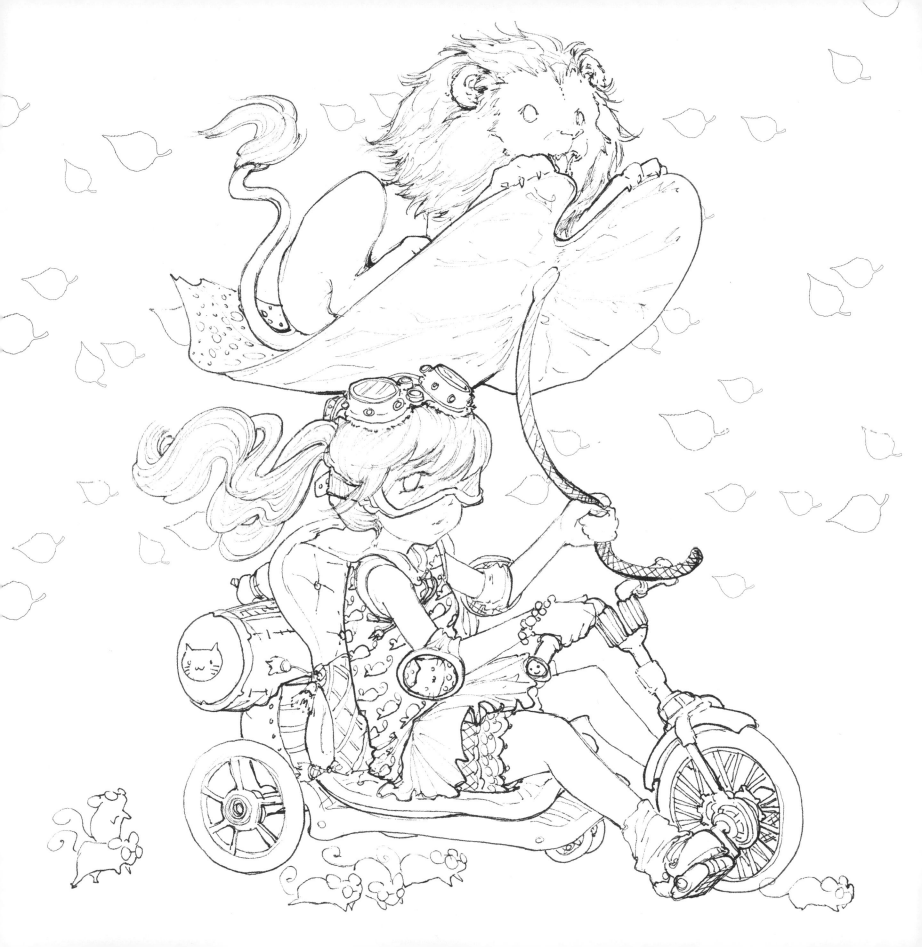

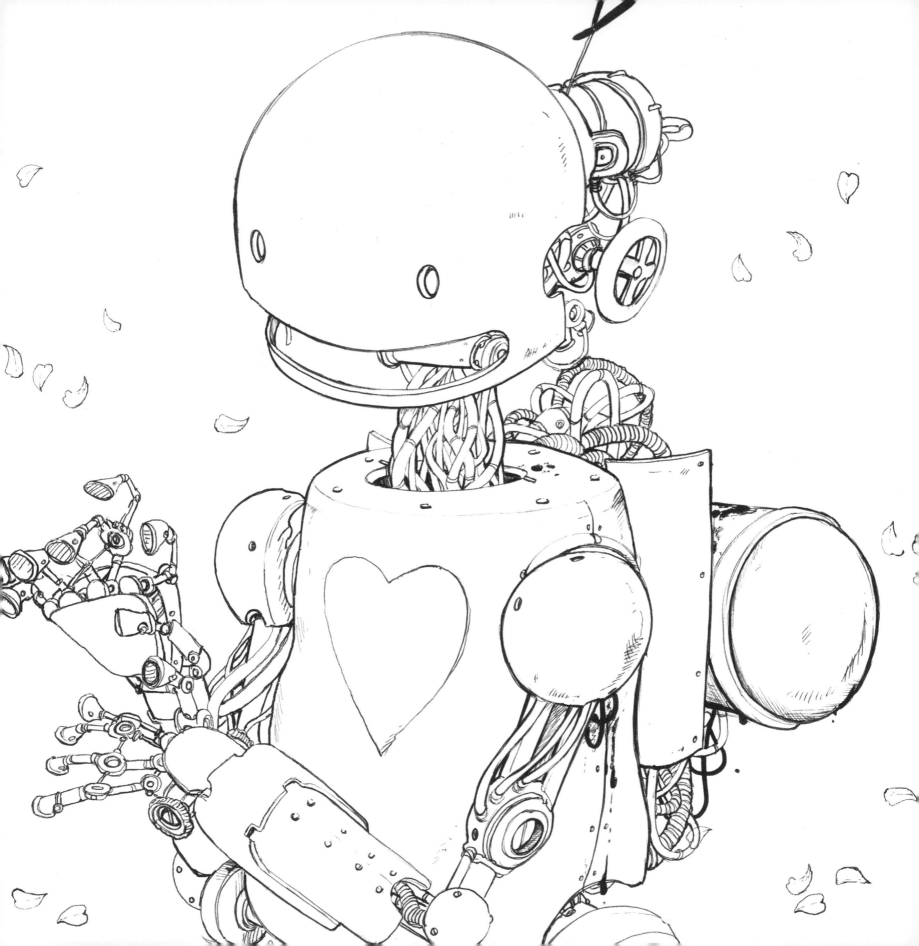

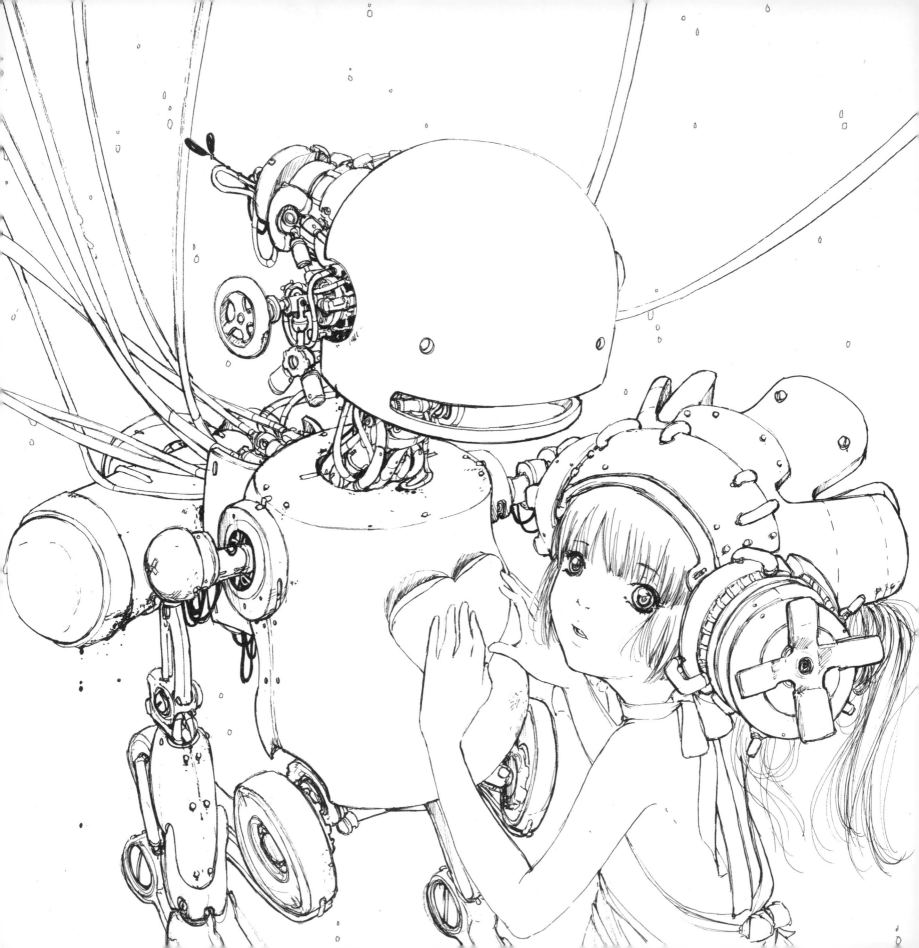

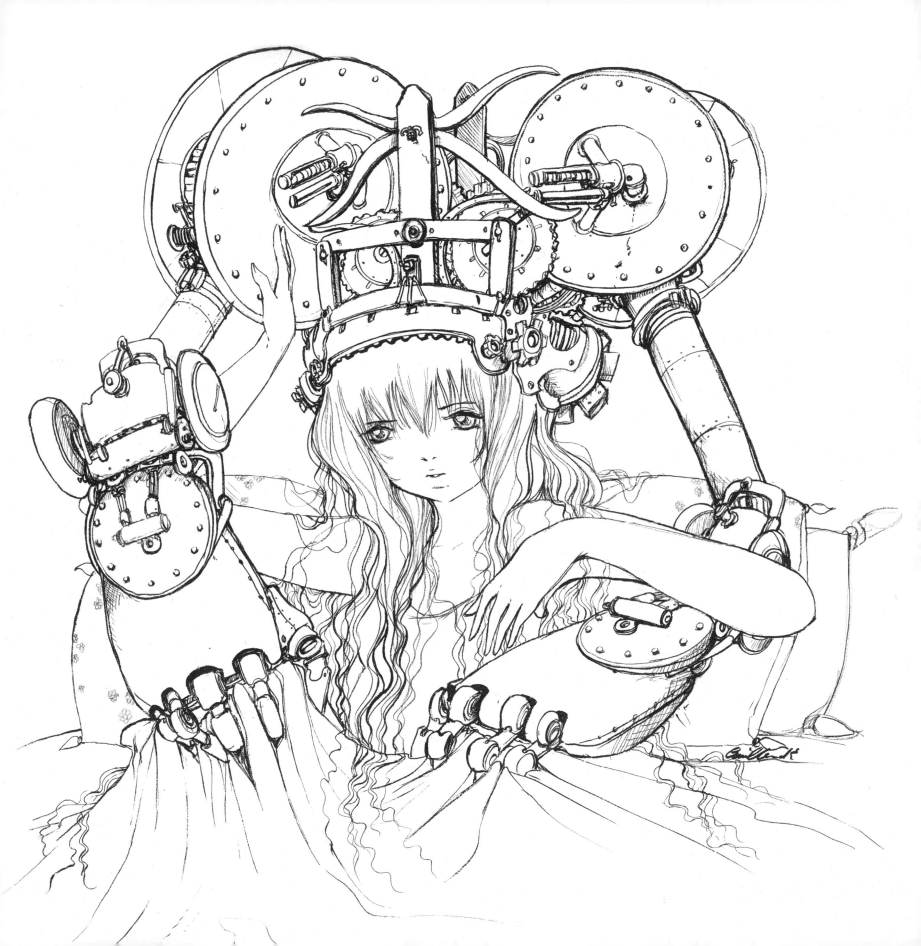

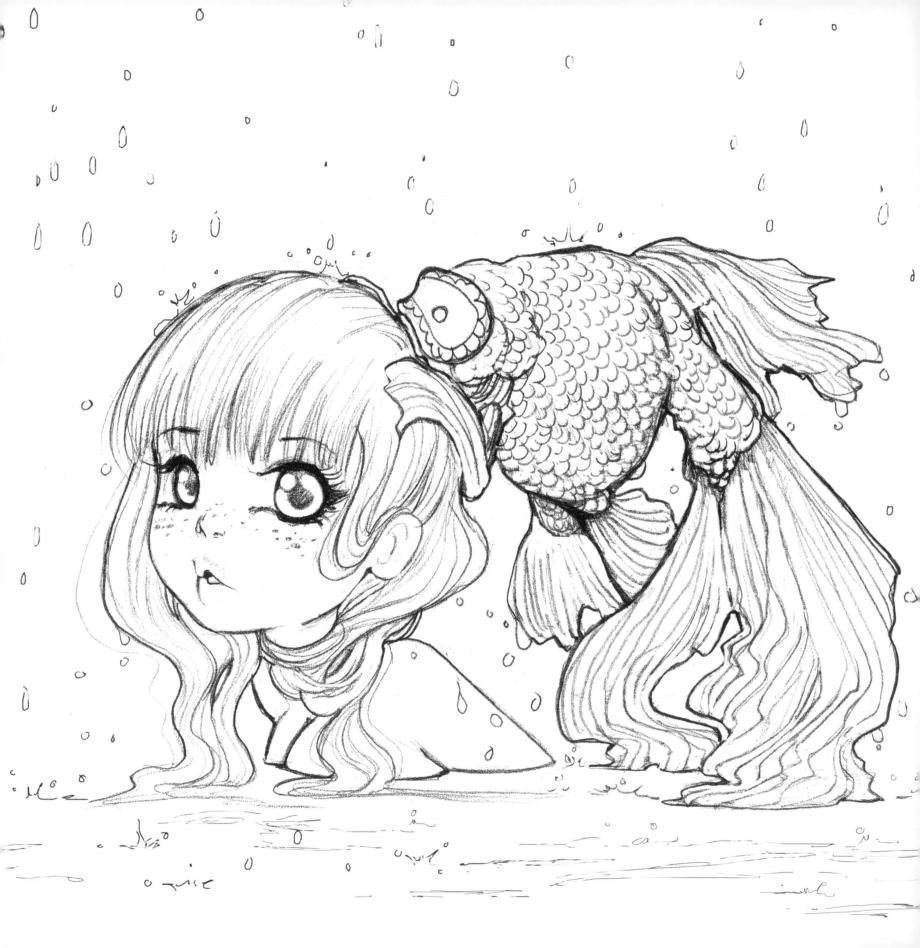

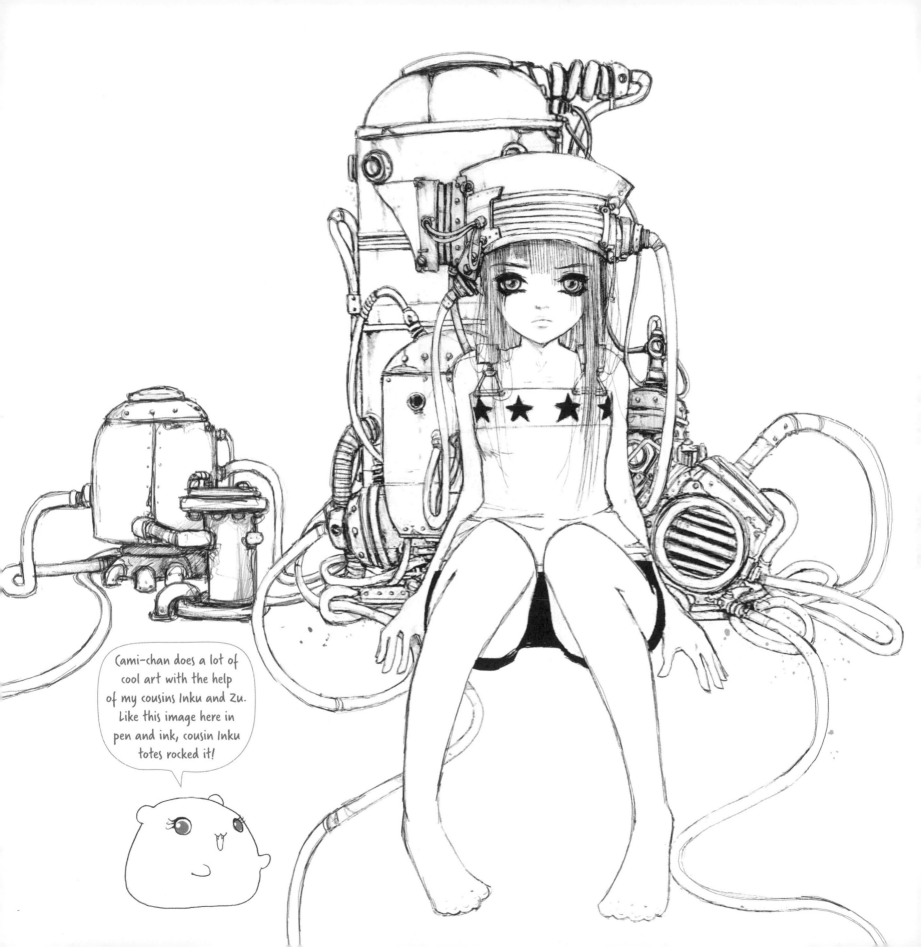

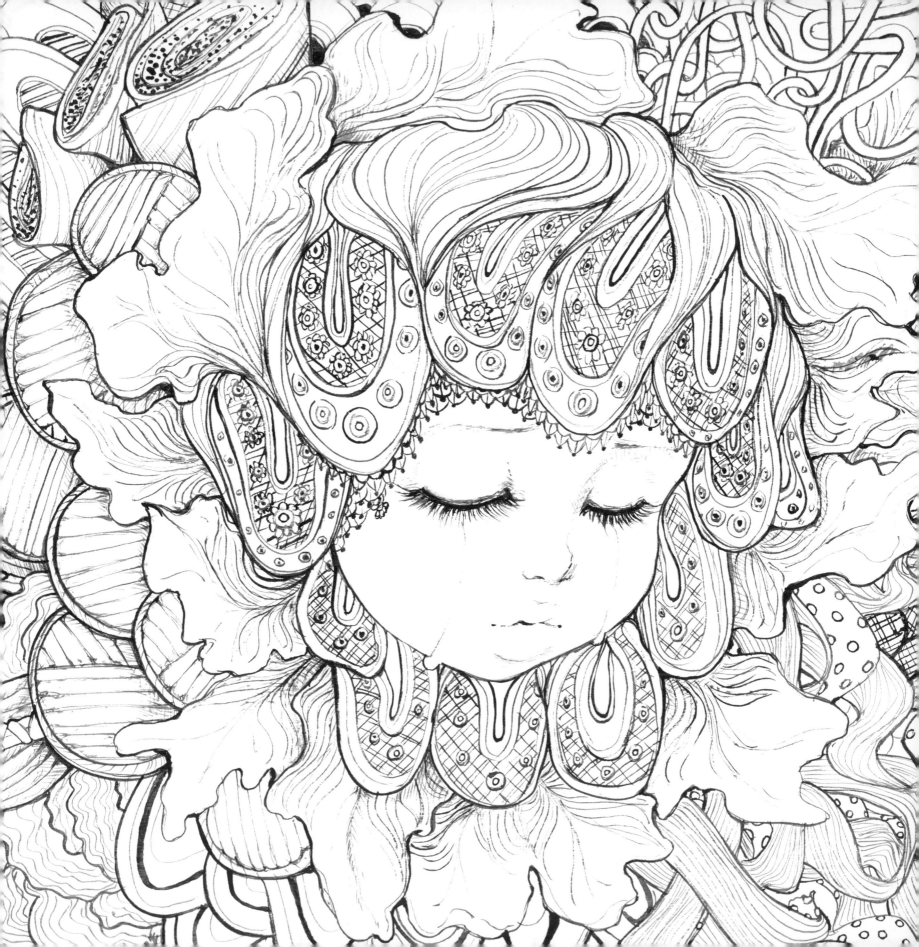

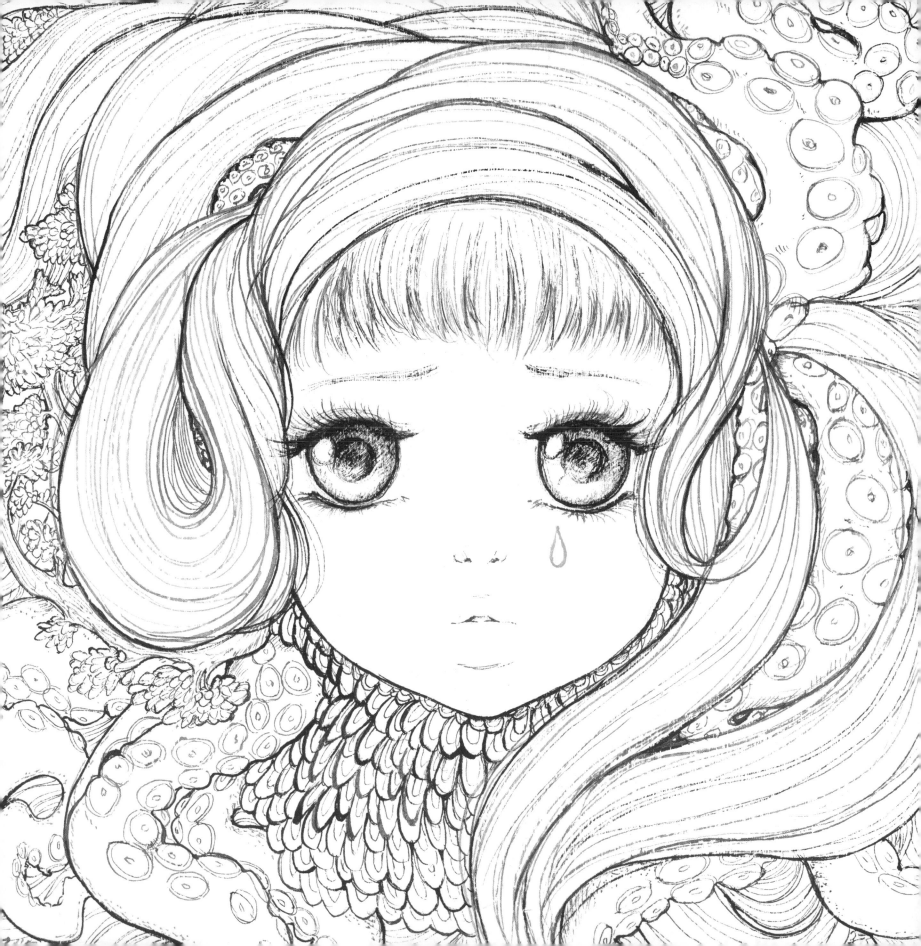

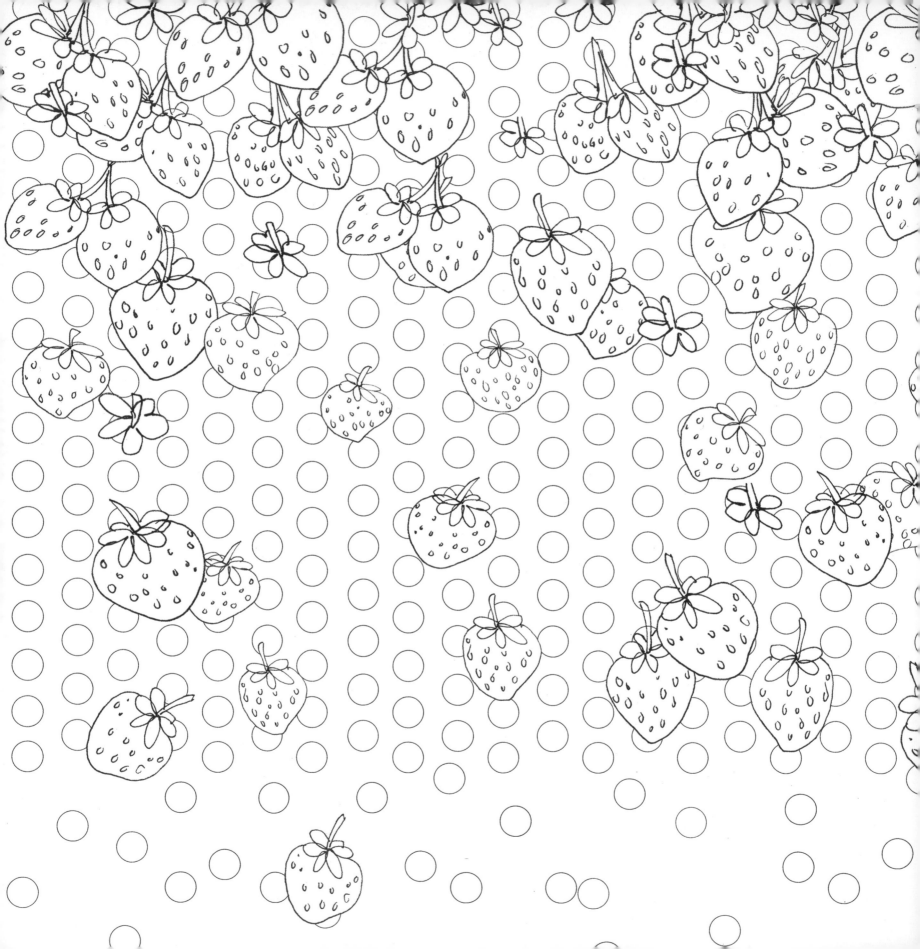

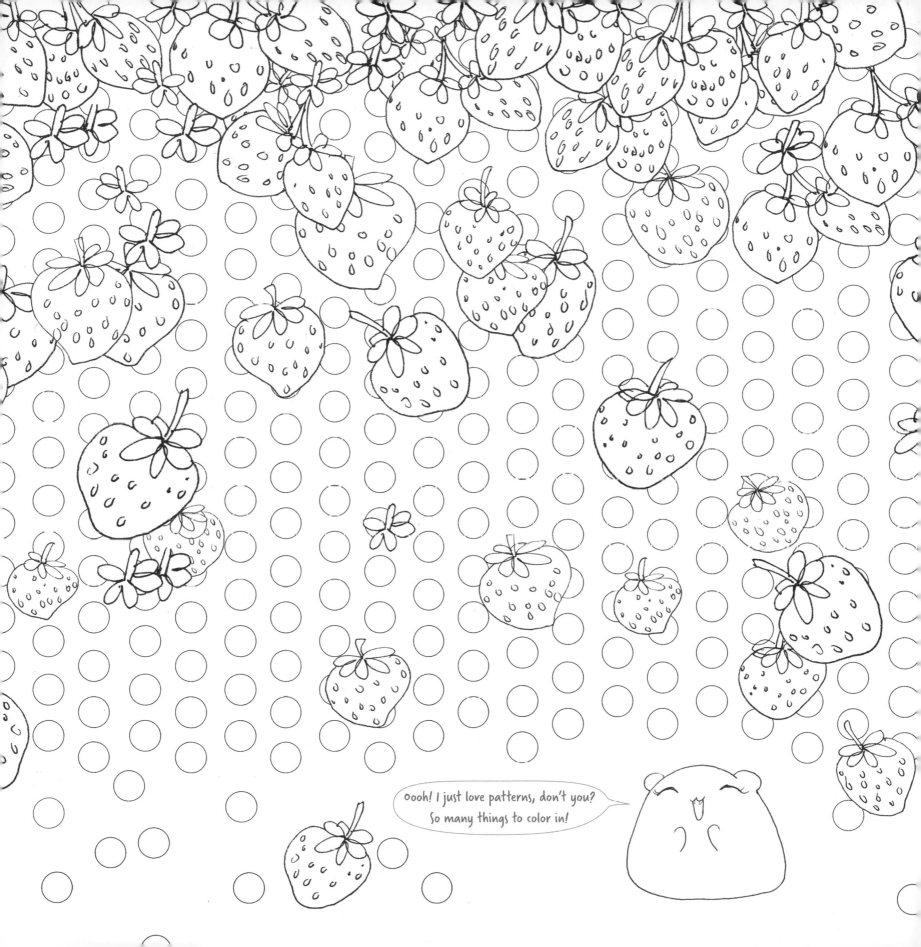

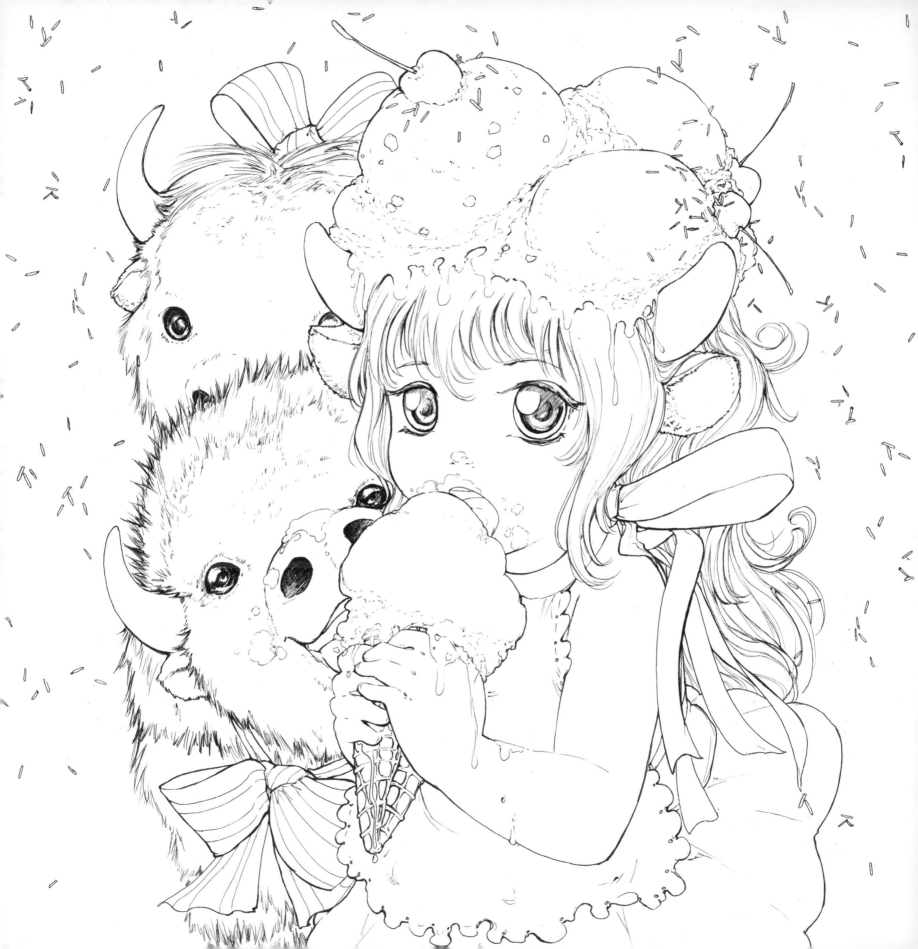

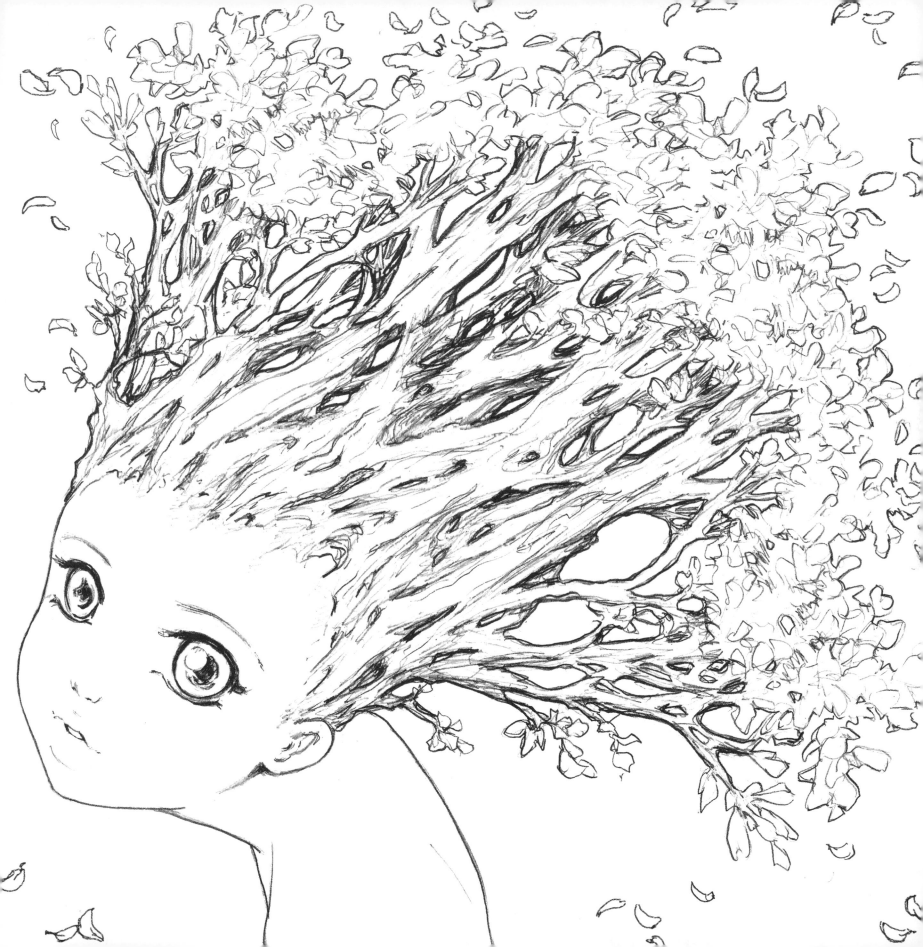

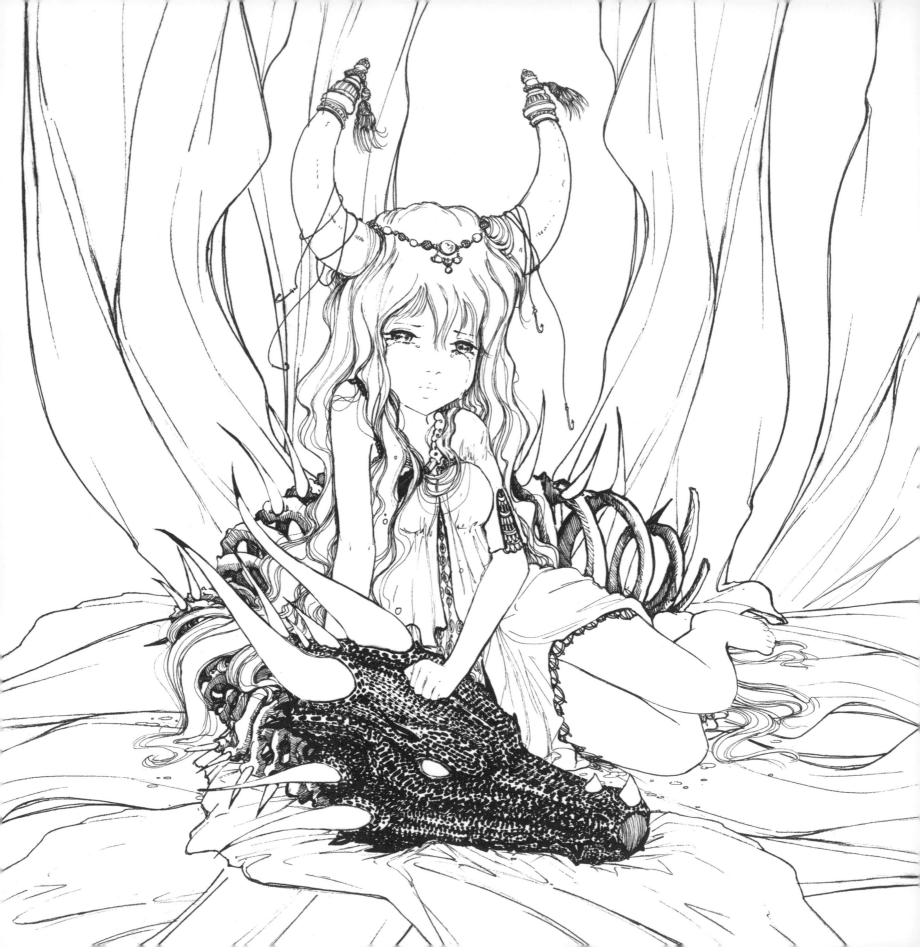

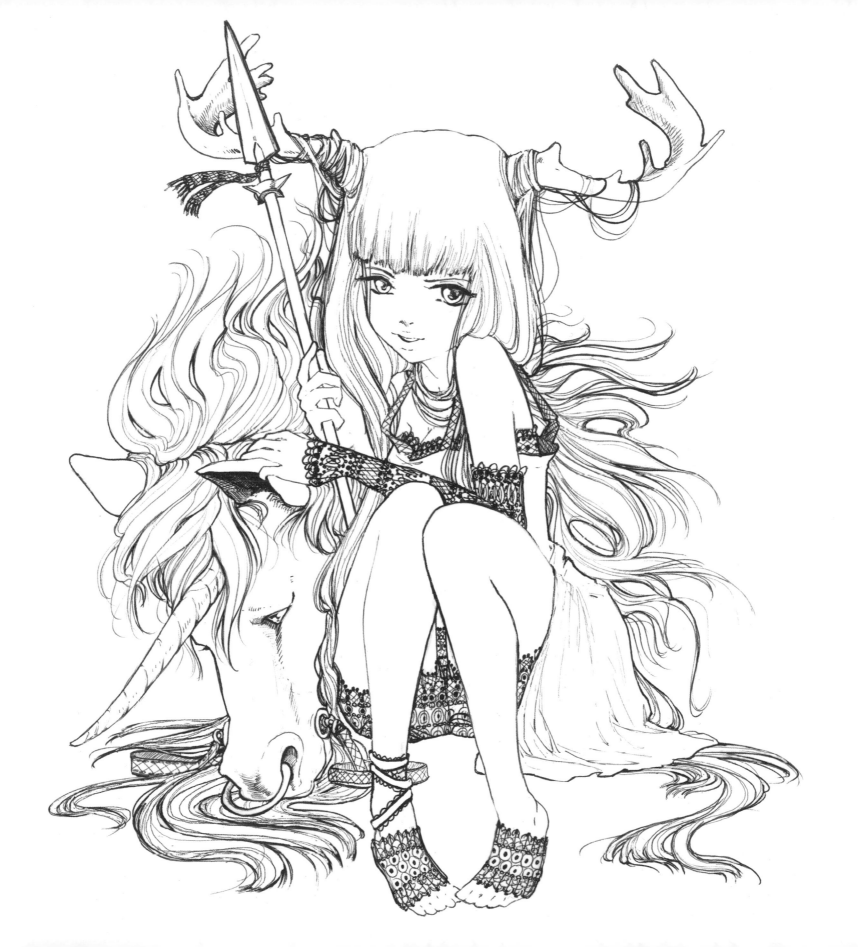

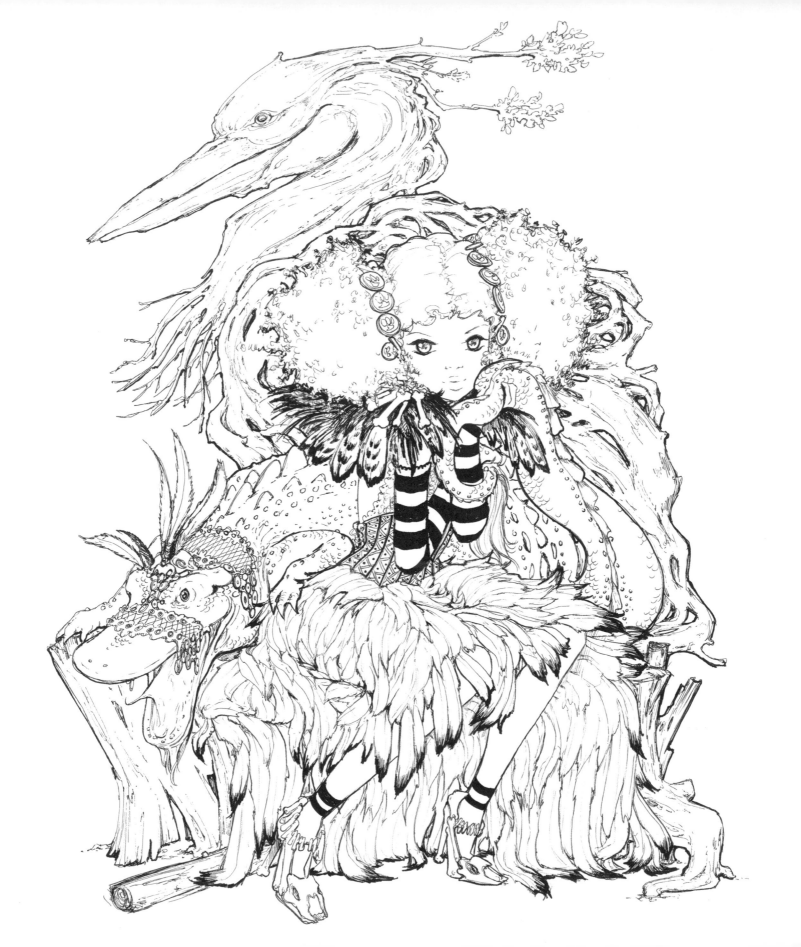

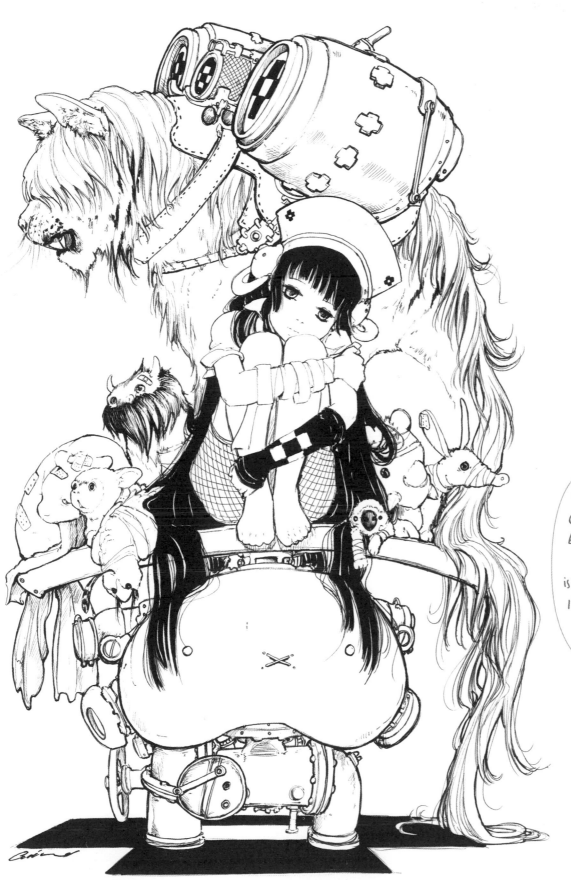

As Camilla's color child, I get asked the following questions a lot: Why doesn't Camilla color all her artwork? Why use only black and white for some pieces? It's simple. Cami-chan loves manga and manga is traditionally black and white. Even though I'm a fan of color, I totes love the simplicity and intricacy of these sorts of images. I bet you can come up with some rad colors for 'em though!

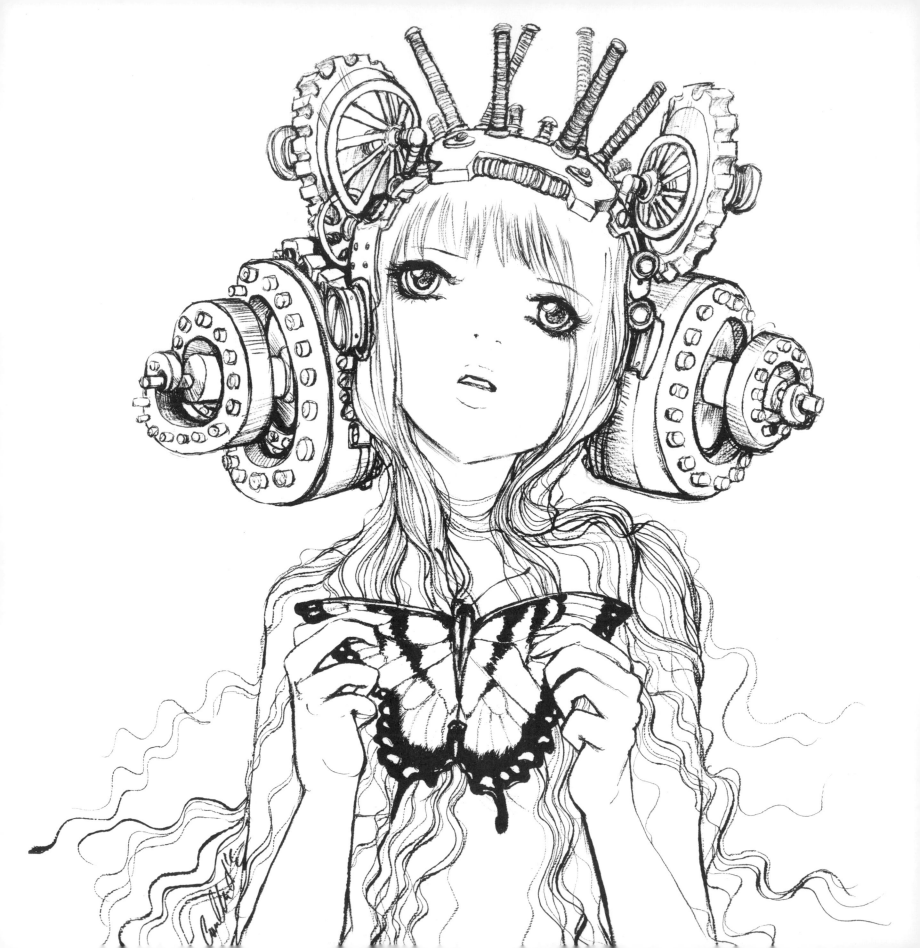

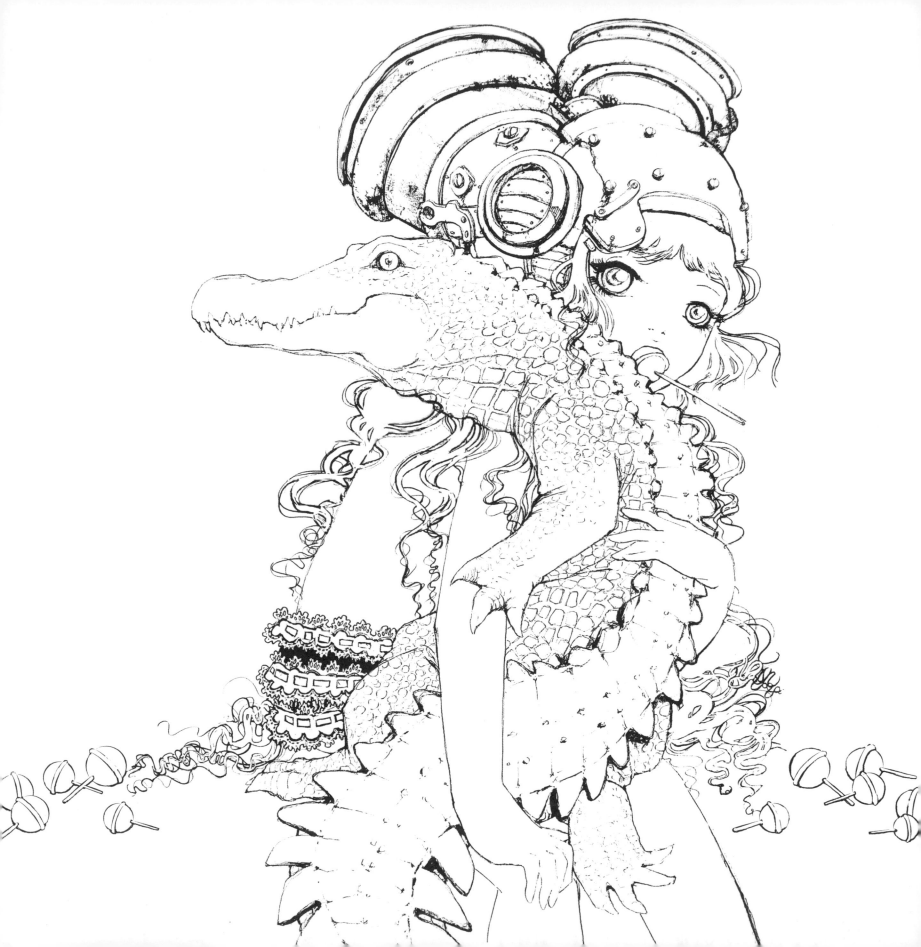

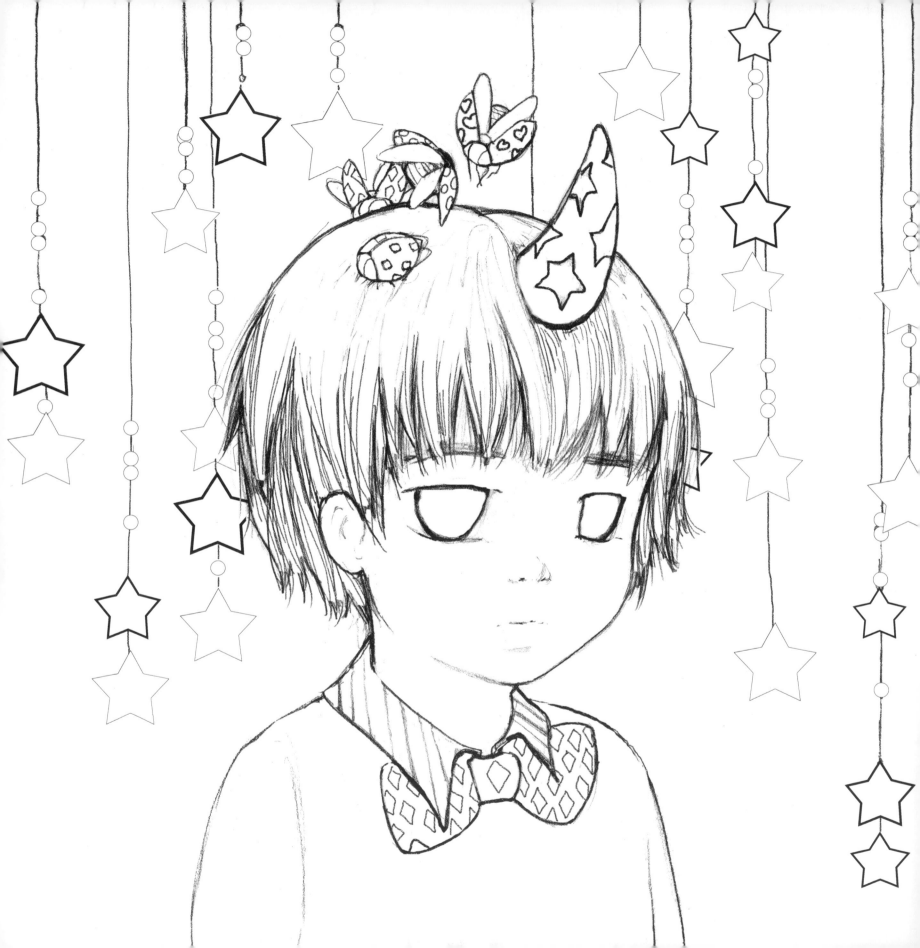

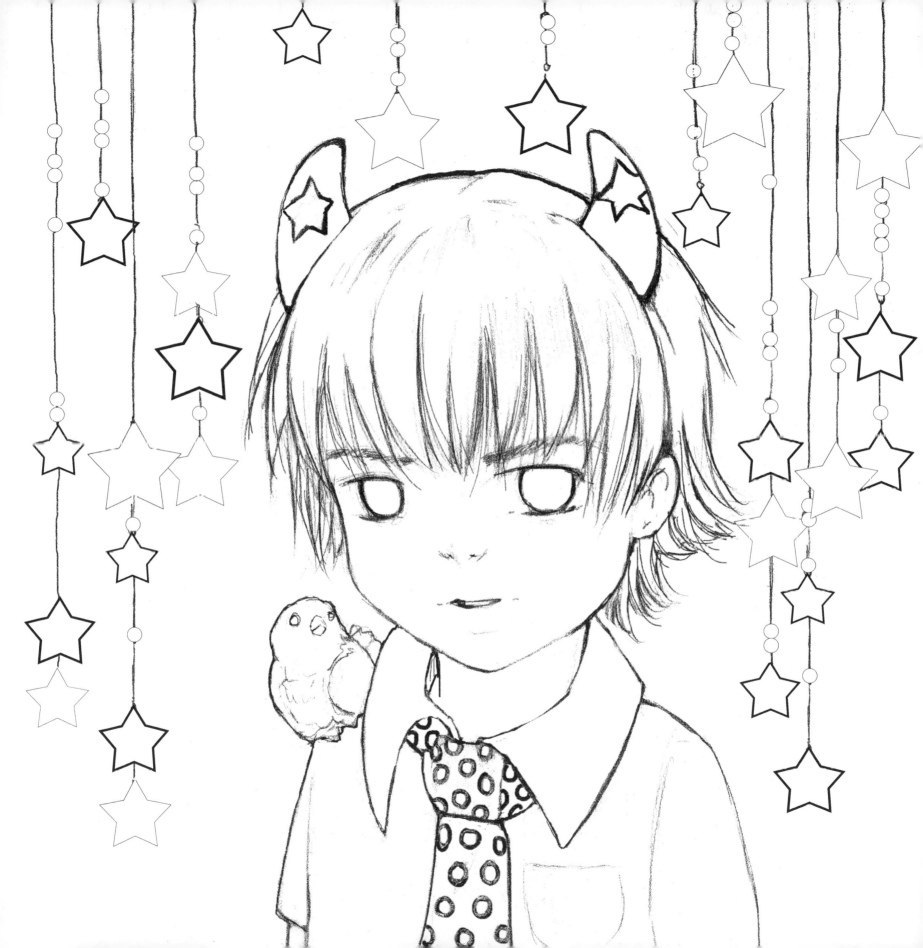

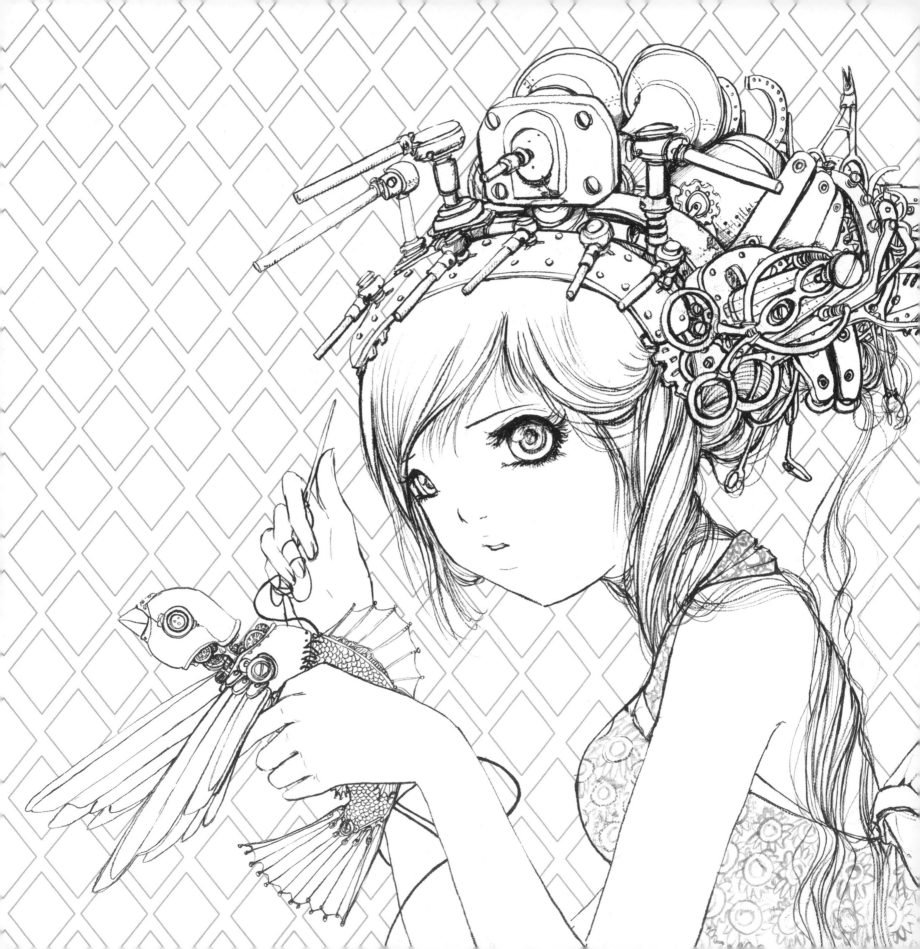

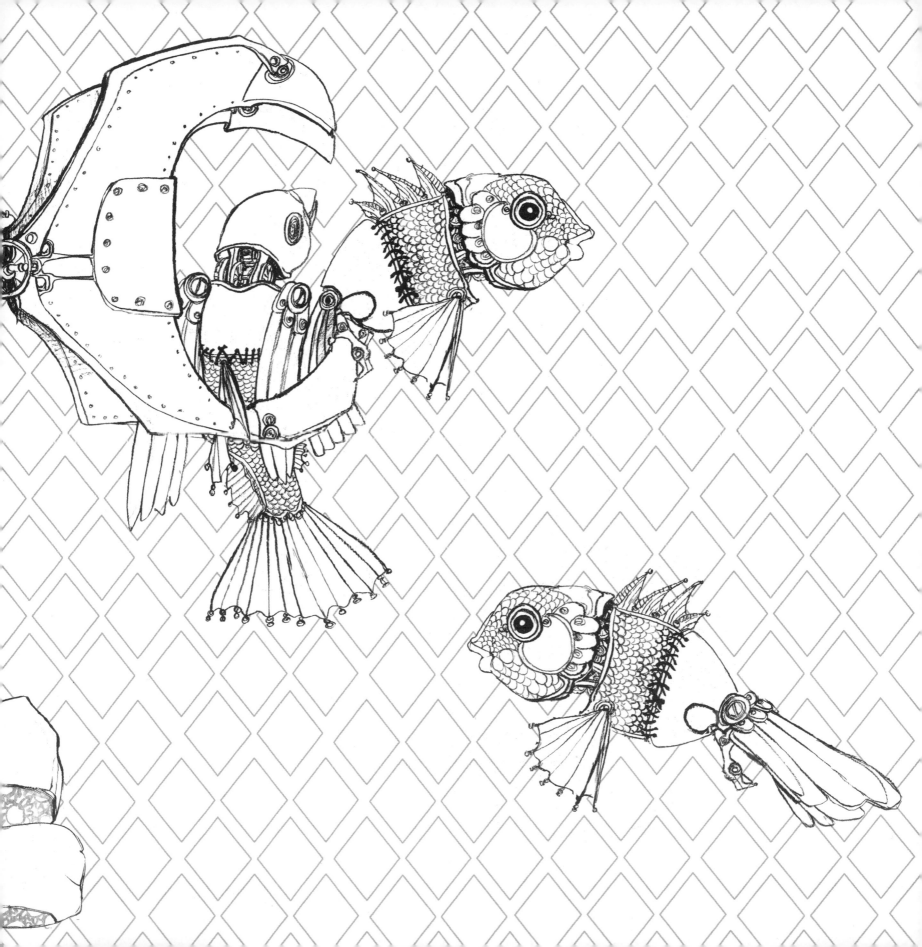

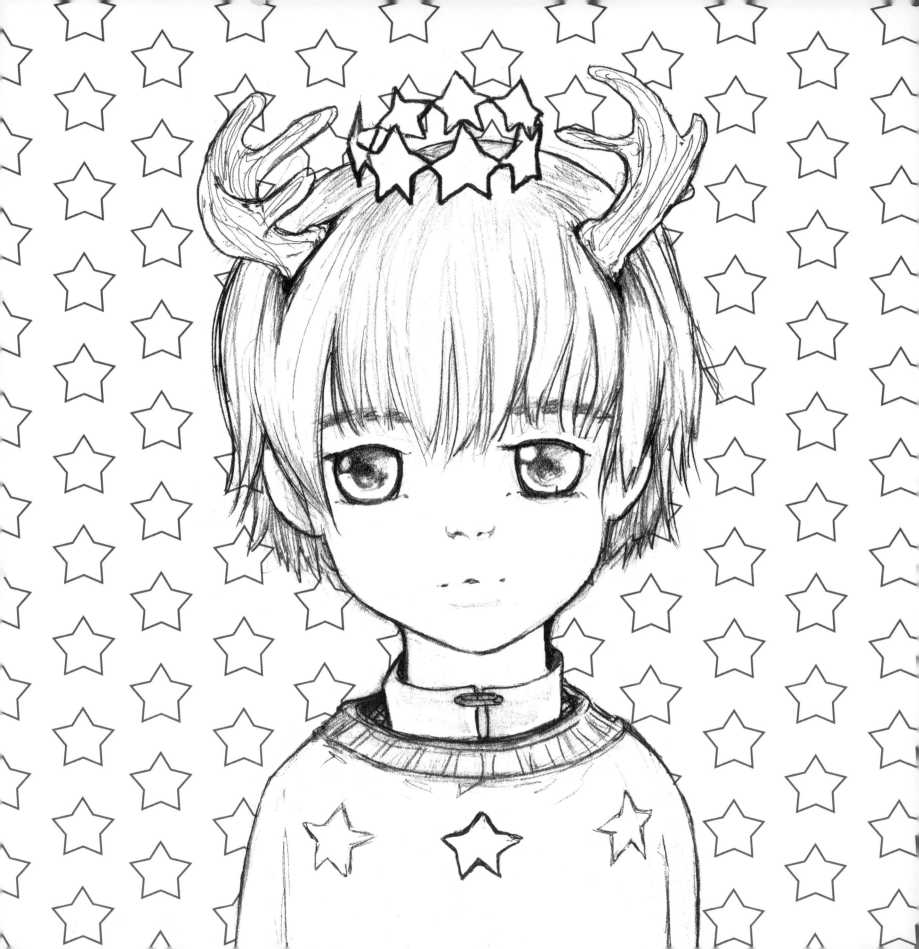

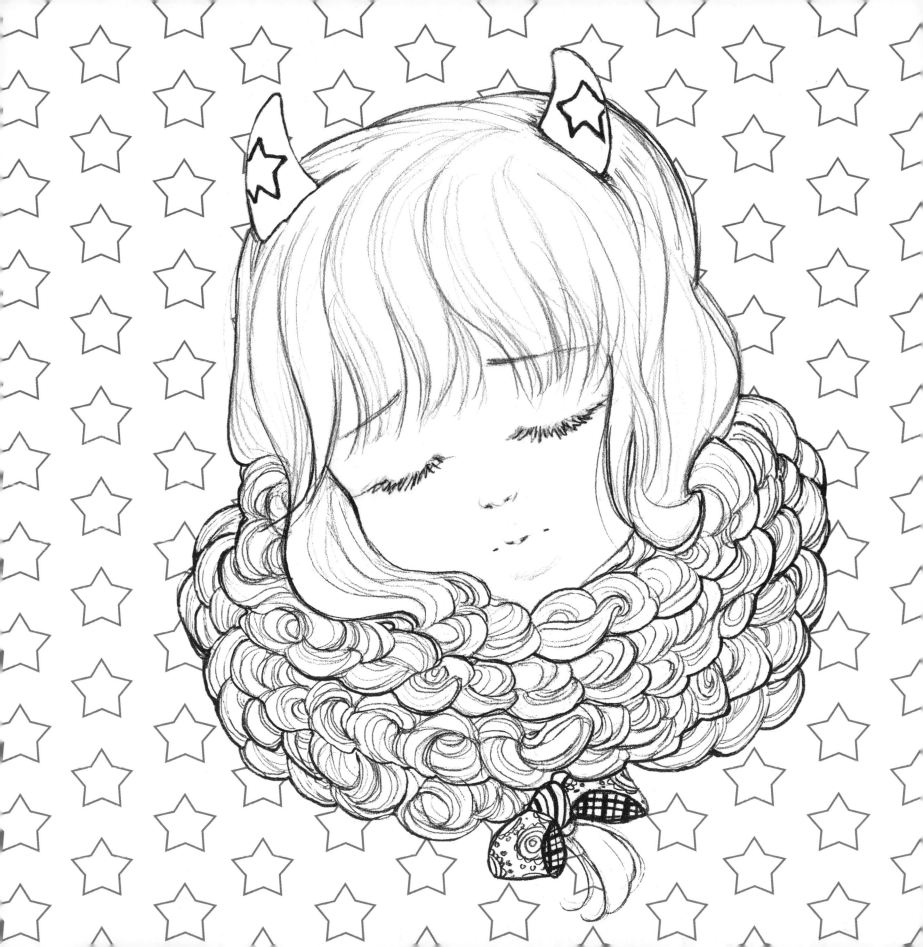

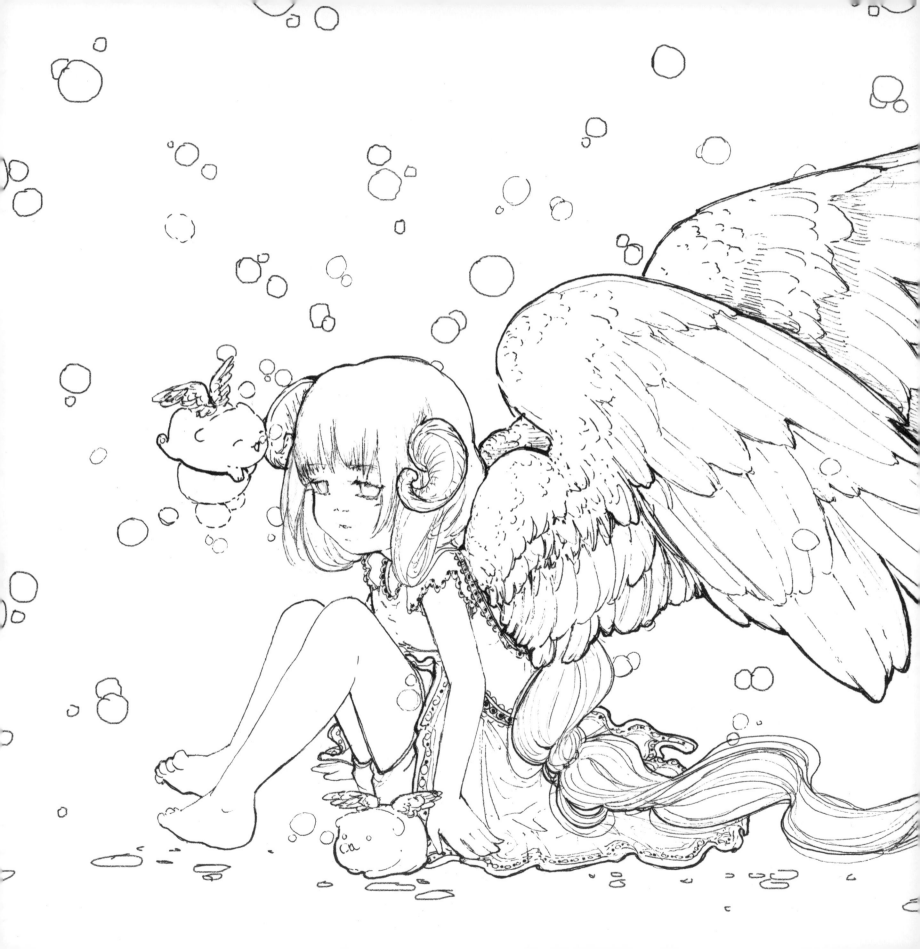

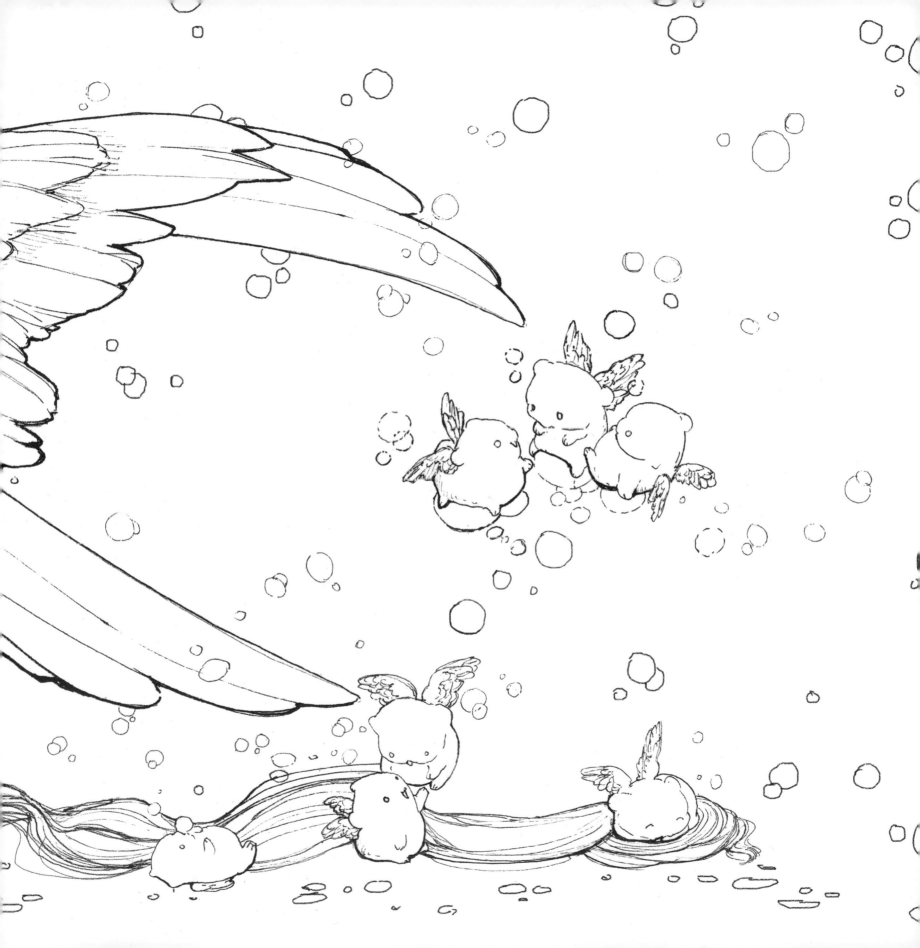

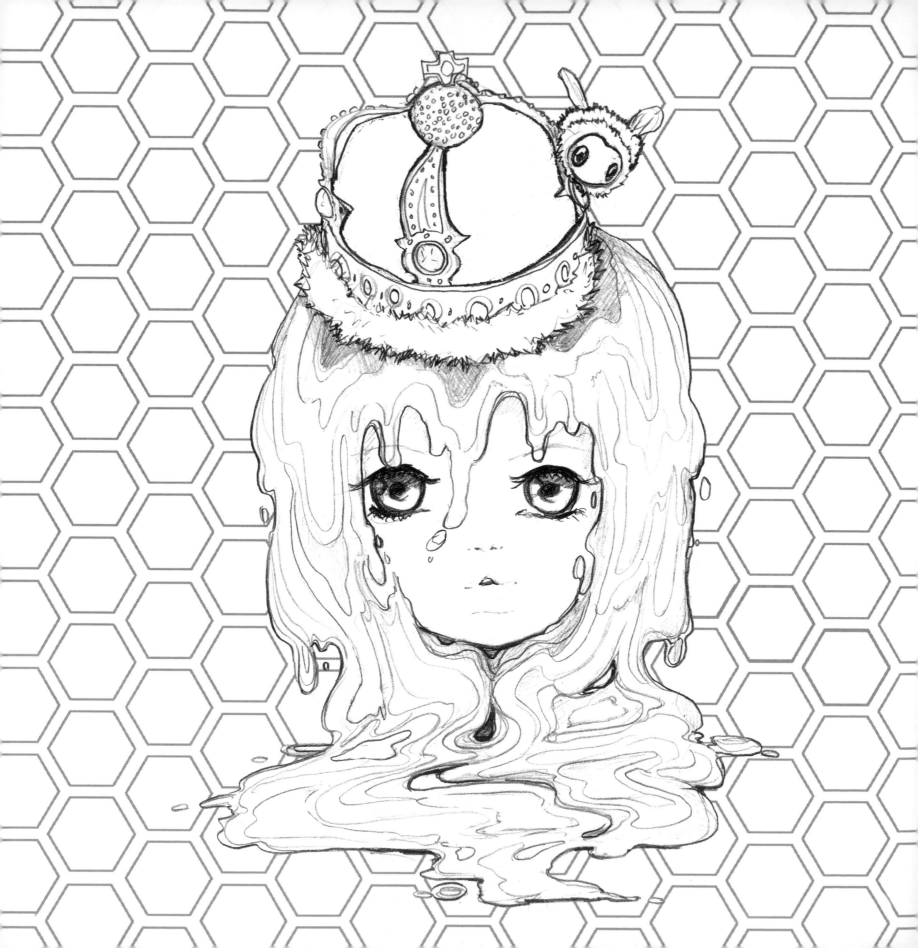

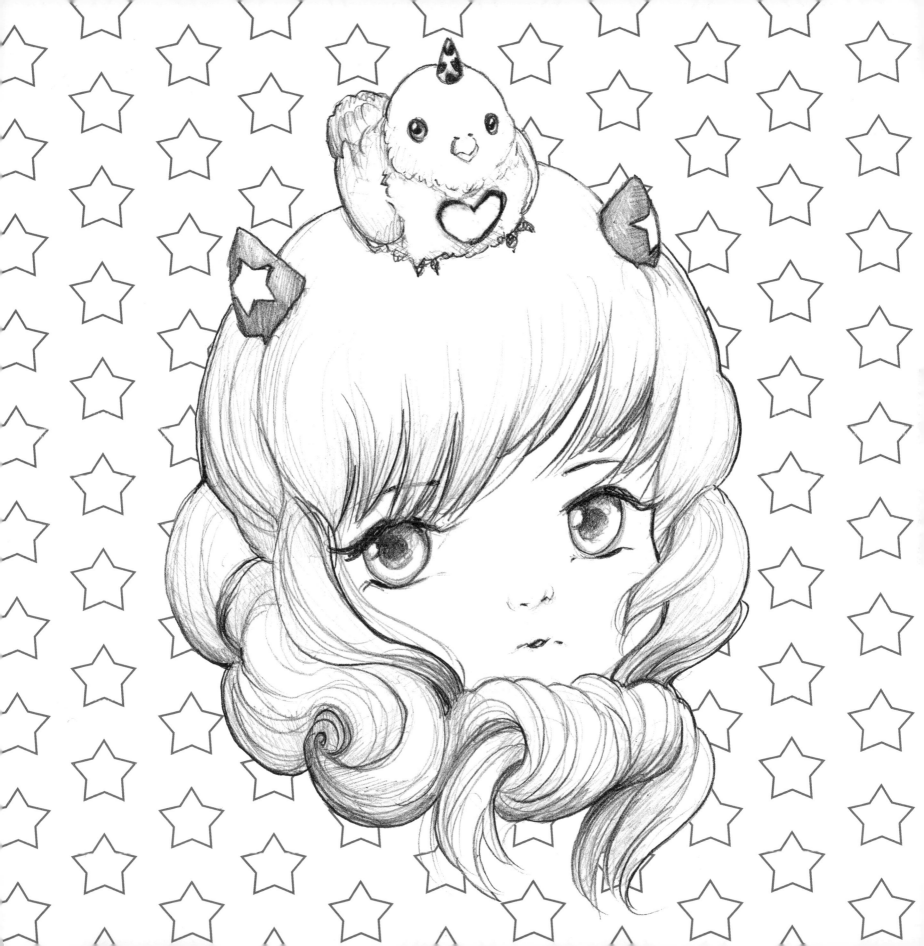

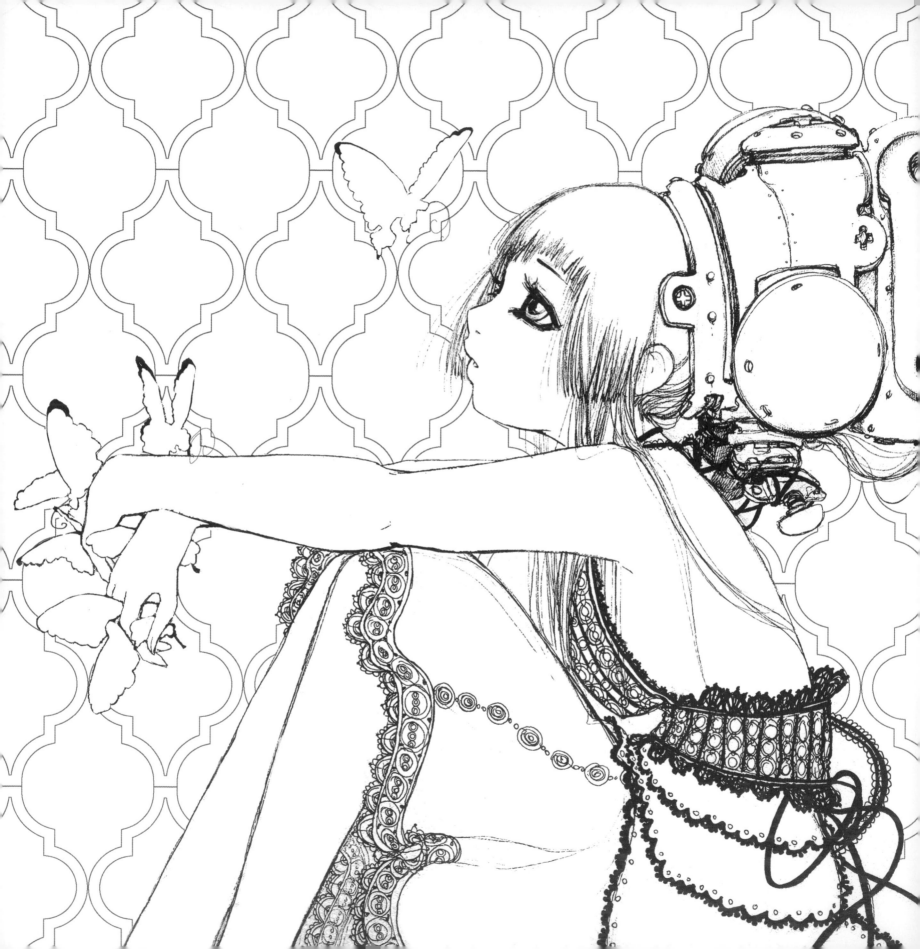

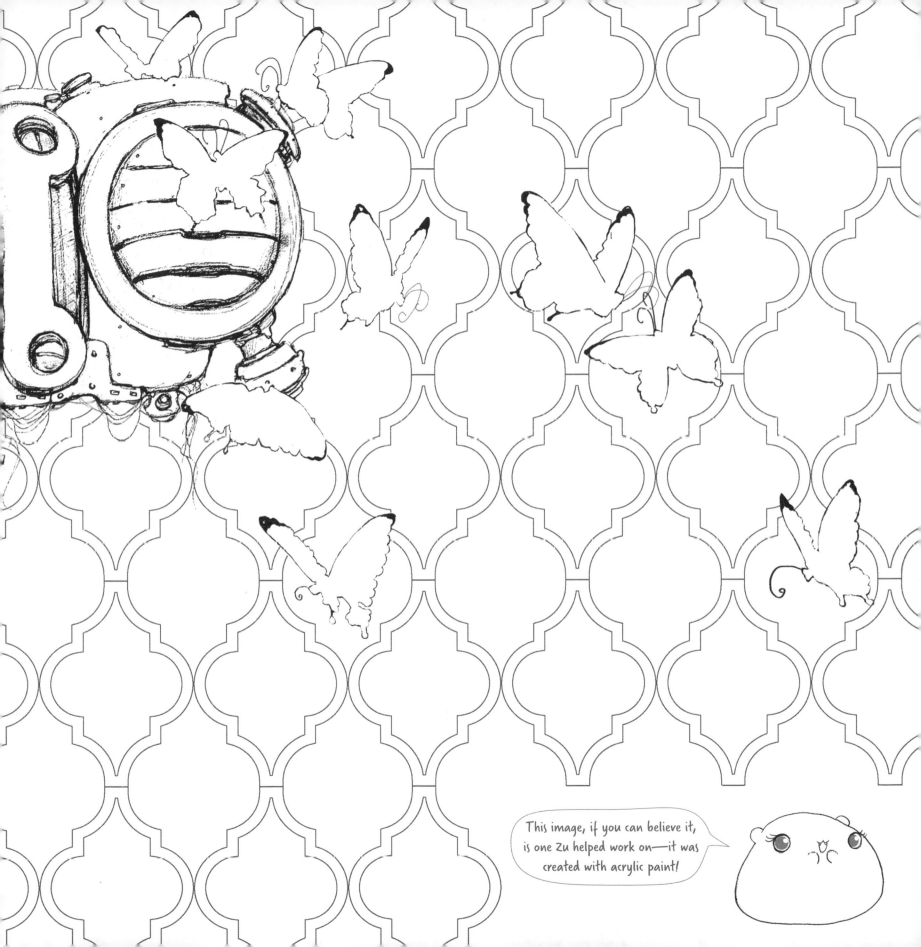

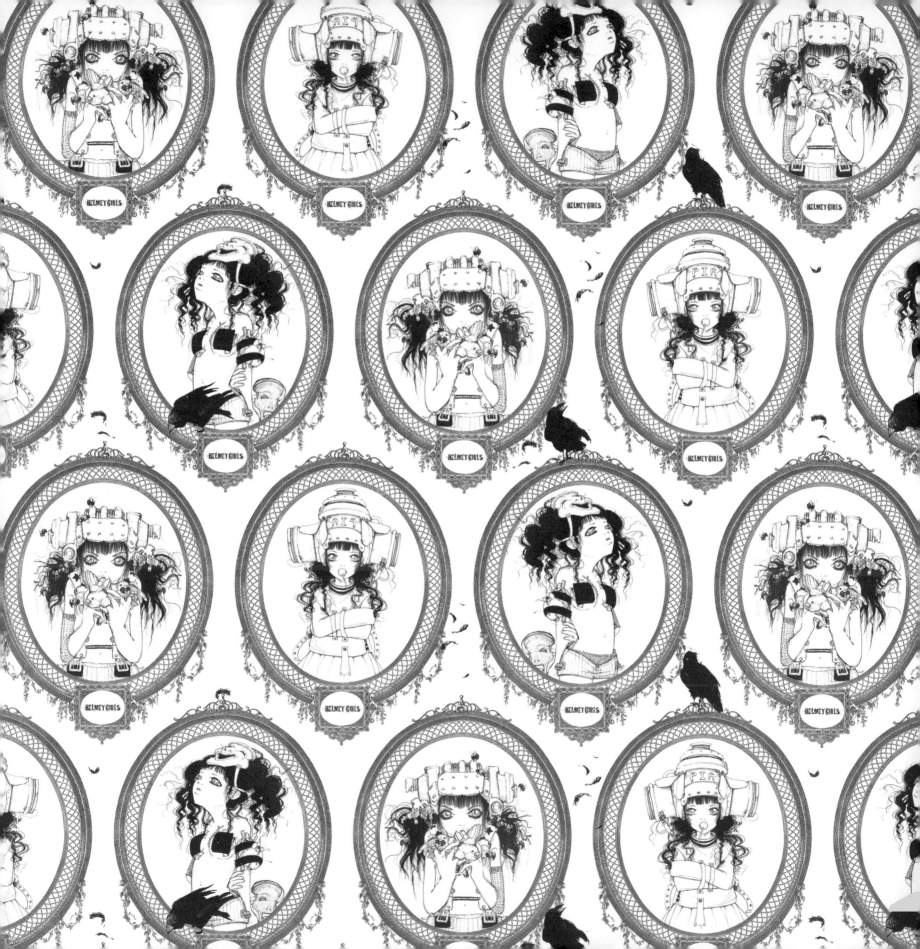

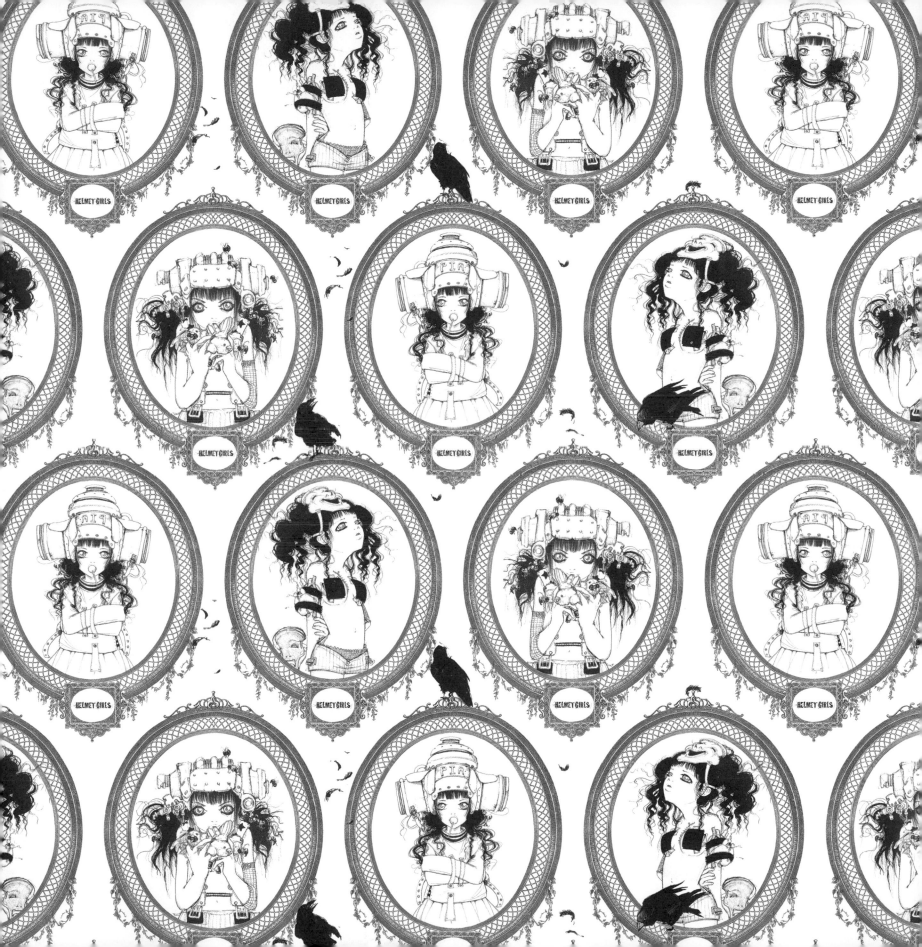

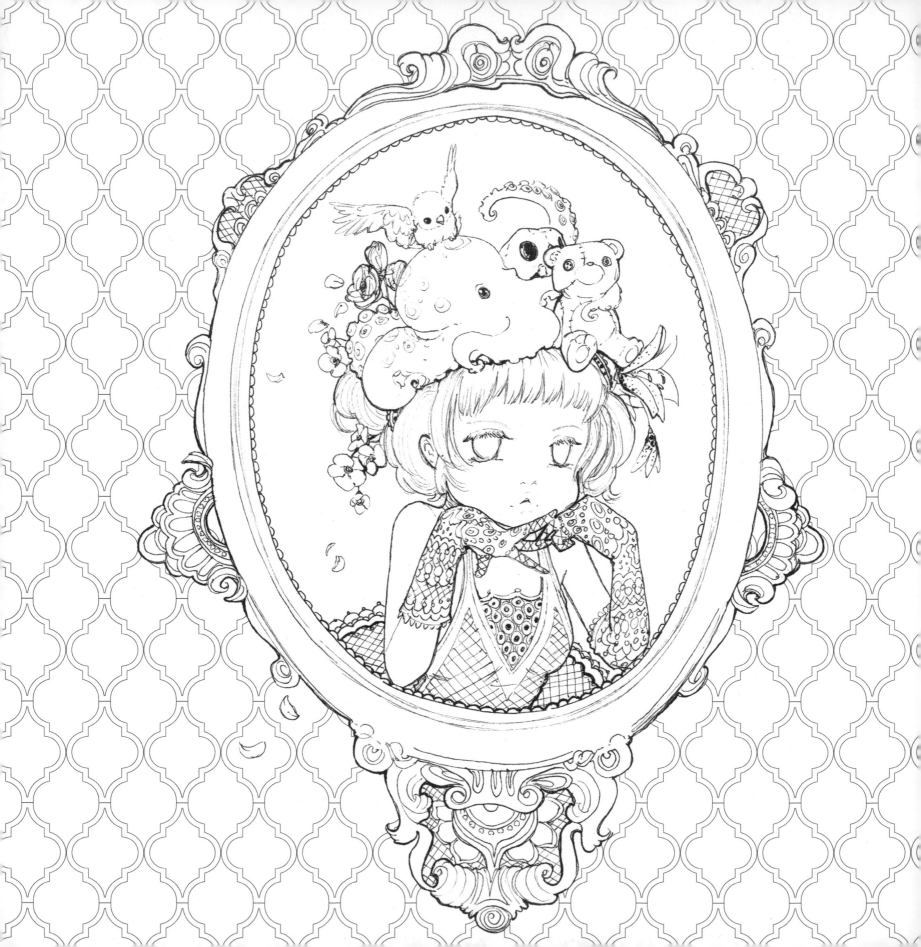

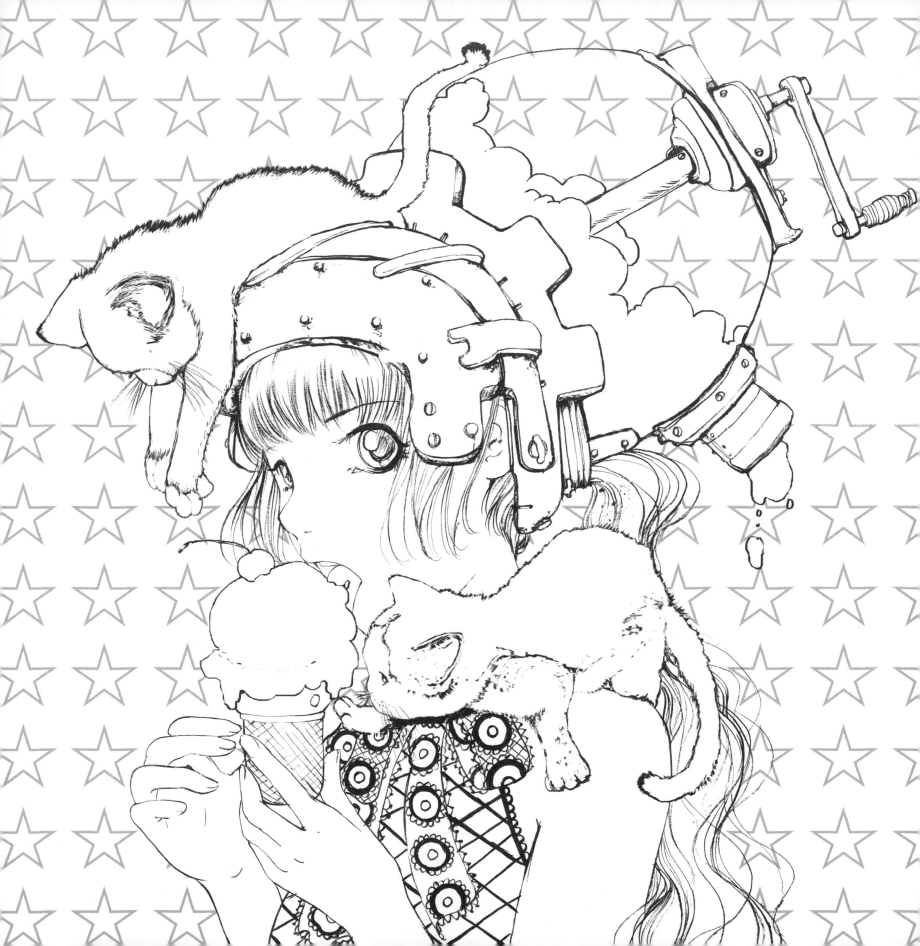

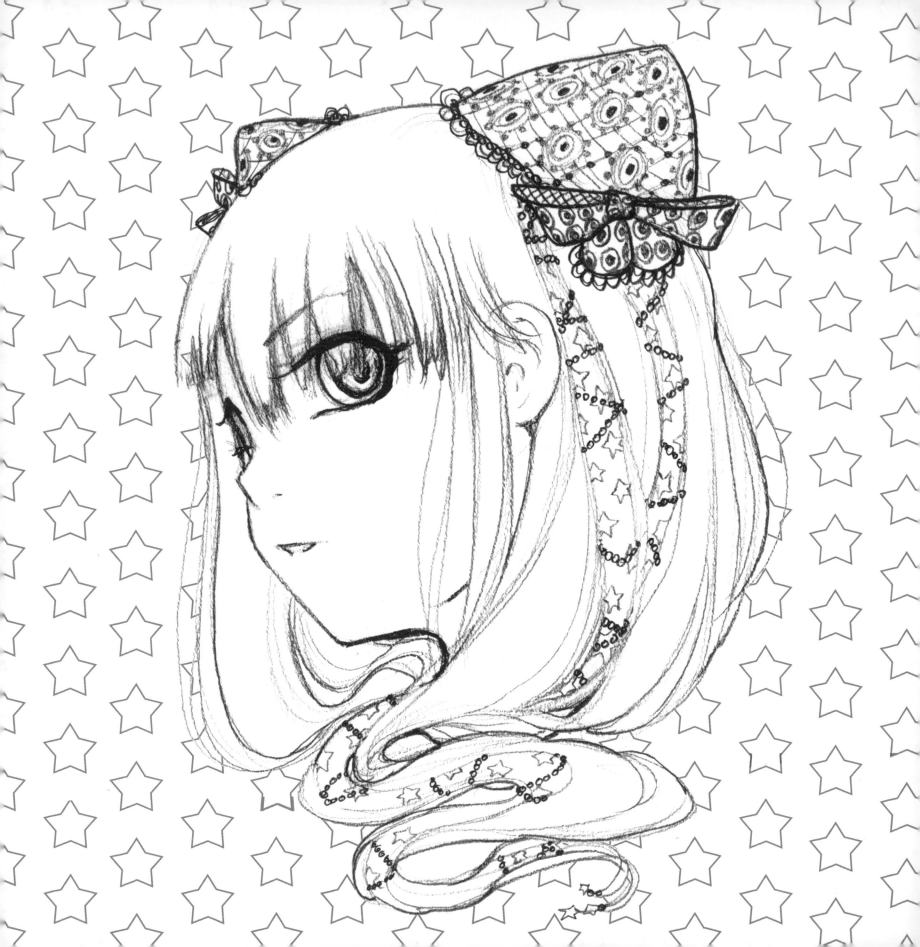

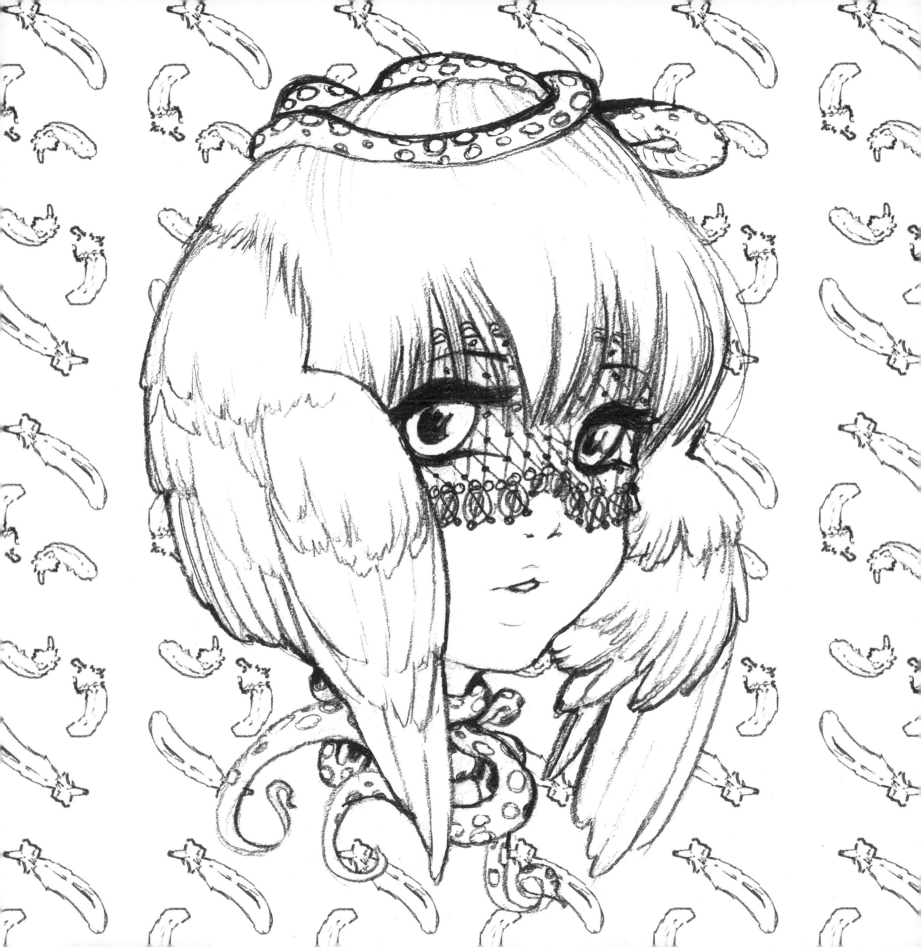

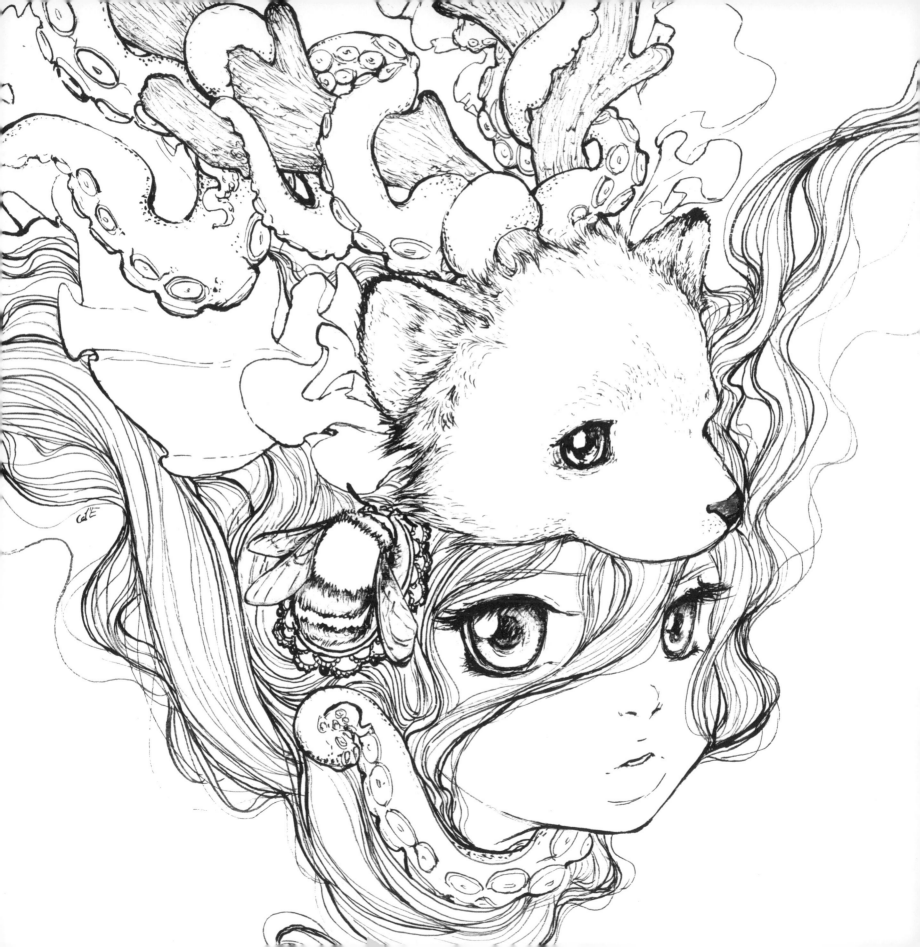

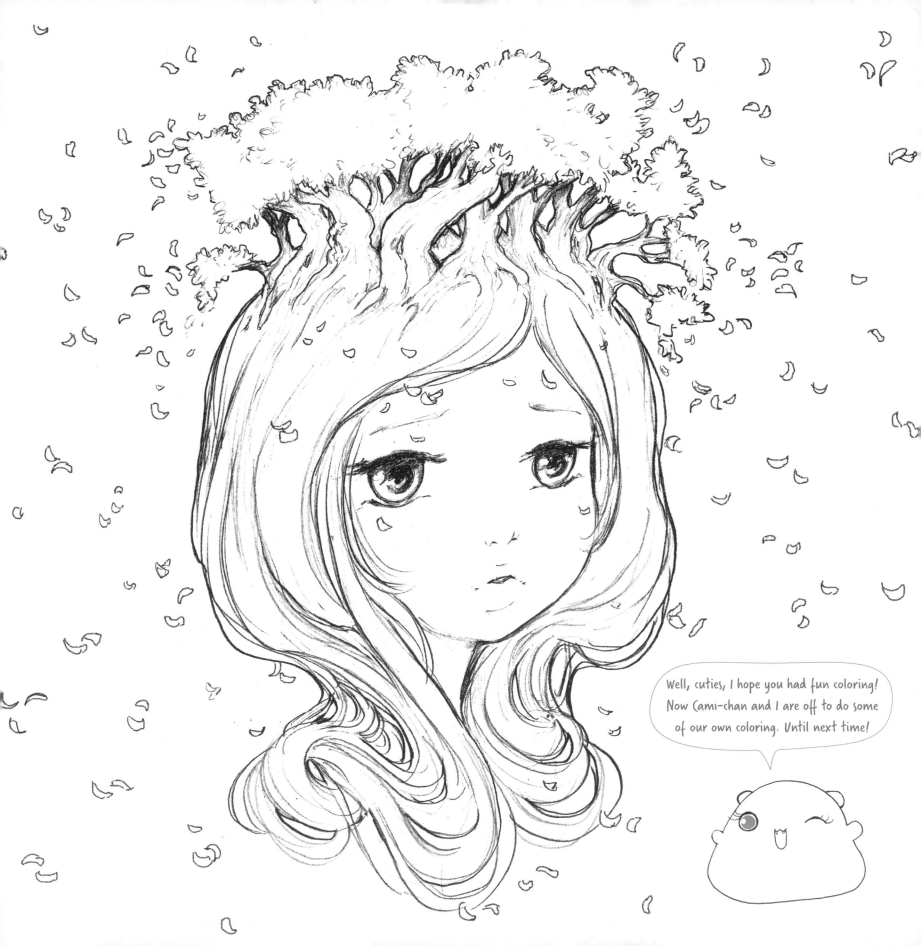

Some illustrations in this work previously appeared as follows:

Page 7: Camilla d'Errico, *The Heart*, 2010, acrylic on canvas.

Page 38: Camilla d'Errico and Oh Pour L'amour Du Chocolat,
Jenny's Ice Cream, 2011, ink on paper. Used with permission.

Pages 42-43: Camilla d'Errico, *Mamma Bot 2.0*, 2011, ink on paper.

Page 44: Camilla d'Errico, *Mamma Bot*, 2010, ink on paper.

Page 47: Camilla d'Errico and BOOM! Studios, *Tanpopo*, *Tanpopo
Volume 1*, © 2012 Boom! Studios. Used with permission.

Page 56: Camilla d'Errico and Fathom Interactive *Calypsu*, 2013,
ink on paper. Based on characters from *Sky Pirates of Neo Terra*.
Used with permission.

Page 57: Camilla d'Errico, *Suma*, 2013, ink on paper. Based on
characters from *Sky Pirates of Neo Terra*. Used with permission.

Page 59: Camilla d'Errico, *Croc O Hug*, 2008, acrylic on canvas.

Pages 70-71: Camilla d'Errico, *Xiomara*, 2008, acrylic on canvas.

Pages 72-73: Camilla d'Errico, *Ladies in Waiting*, 2010, acrylic on canvas
and digital painting. Altered art by Milton & King used with permission.

Page 75: Camilla d'Errico, *Cherries Jubilee*, 2011, acrylic on canvas.

Trade Paperback ISBN: 978-0-3995-7847-2

Printed in China

Design by Chloe Rawlins

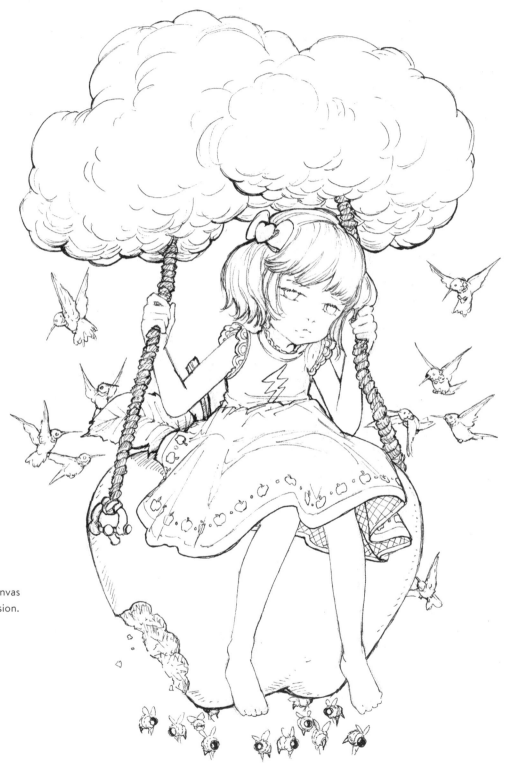